EAGLE
TRANSFORMING

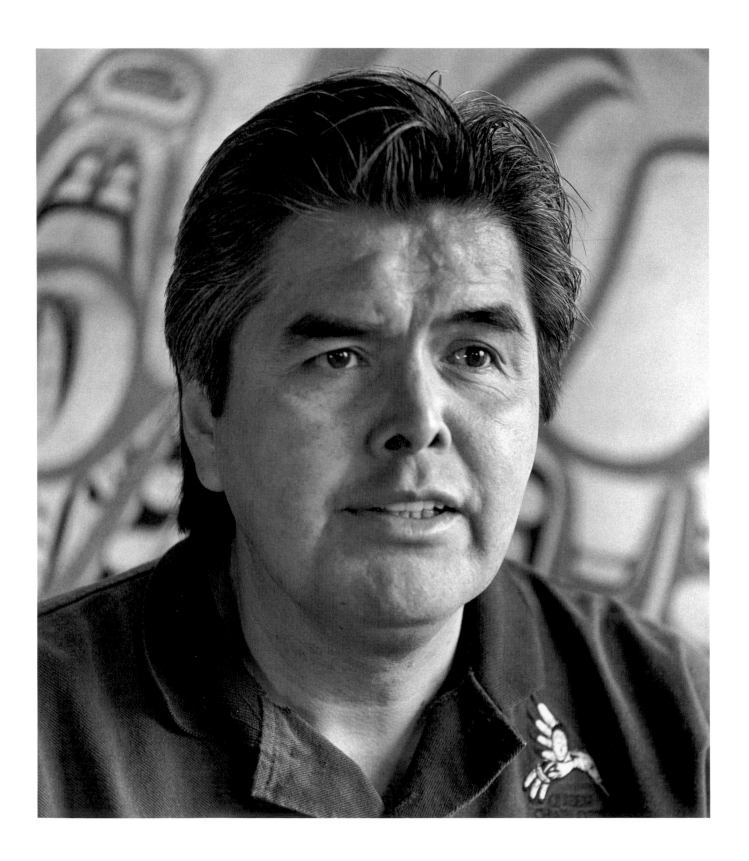

EAGLE
TRANSFORMING
THE ART OF ROBERT DAVIDSON

ULLI STELTZER ROBERT DAVIDSON

Douglas & McIntyre
Vancouver/Toronto

University of Washington Press
Seattle

94 95 96 97 98 5 4 3 2 1

Douglas & McIntyre
1615 Venables Street
Vancouver, British Columbia V5L 2H1

Canadian Cataloguing in Publication Data

Steltzer, Ulli, 1923 –
Eagle transforming

ISBN 1-55054-099-8

1. Davidson, Robert, 1946 – 2. Haida Indians — Art. 3. Indians of North
America — British Columbia — Art. I. Davidson, Robert, 1946 – II. Title

N6549.D397S7 1994 730'.92 C94-910210-5

Published simultaneously in the United States of America by
The University of Washington Press
PO Box 50096
Seattle, Washington 98145-5096

Library of Congress Cataloging-in-Publication Data

Davidson, Robert, 1946 –

Eagle transforming : the art of Robert Davidson / photographs by
Ulli Steltzer : text by Robert Davidson : introduction by Aldona Jonaitis.

 p. cm.

ISBN 0-295-97371-4

1. Davidson, Robert, 1946– . 2. Haida artists — Biography. 3. Haida
sculpture. 4. Haida Indians — Biography. I. Steltzer, Ulli. II. Title.

E99.H2D3929 1994

730'.92 — dc20 94-6768
 CIP

Editing by Saeko Usukawa
Design by Jim Skipp
Cover photograph of Robert Davidson working on
Breaking the Totem Barrier, 1989, by Ulli Steltzer
Frontispiece photograph of Robert Davidson, 1994, by Ulli Steltzer
Typeset by NovaType Inc.
Published with assistance from the British Columbia Heritage Trust
Printed and bound by CS Graphics Pte Ltd in Singapore

CONTENTS

*To my brother, Reg Davidson, who has been one of
my main supporters over the years and who has
helped me in realizing the larger projects.
To my mother, Vivian, and to my father,
Claude Davidson, and their generation, who
missed an integral part of their lives in being
denied their own language and cultural
background. And to my* naanii *Florence and*
tsinii *Robert, and their generation, who were the
link to our ancestral past. And lastly, to our
ancestors, who laid down the foundation.*

PREFACE

It is said that language is the key to a culture. In the Haida language, as in those of many First Nations here in the Americas, we do not have a word for art. So for lack of a better word, I will borrow the English word "art." We Haida were once surrounded by art. Art was one with our culture. We had art that was sacred, brought out only for certain ceremonies. We also had art that was on permanent display, validating our place in the world. Art is our only written language. It documented the histories of our families; it documented our progress as a people. Throughout our history, art has kept our spirit alive. Now, art is helping us to reconnect with our cultural past. It is also helping to bridge the gap of misunderstanding between our culture and yours.

I feel that our artform fits in with all the other categories of great art. It fits in with the great art of Egypt, the great art of Greece, the great art of Europe and Asia. Until recently, however, assessments of Haida art have placed too much emphasis on ethnology or anthropology and not enough on artistic merit. This oversight is due to lack of knowledge and lack of acceptance of it as art, but that is changing.

The Haida artform is a highly developed one. It is very disciplined and very precise, very stylized, but it also has a lot of room for innovation and creativity.

When I began to explore the artform, I didn't realize how closely it was connected to the culture and ceremony. You cannot separate the art from the ceremony. For me, first came the artform, second came song and dance, third came the integration of the artform with song and dance. The fourth I am just starting to understand, and that is ceremony: I feel that it is a very large and important part of being Haida.

Art is a gift from the spirit world. We all have the ability to visualize – that is our connection to the spirit world. When we crystallize these ideas – that is, bring them into this world, we are giving birth to new images, new ideas and new directions.

The inspiration for my pieces comes from ceremonial and personal experience. The big challenge today is to give meaning to the artform, meaningful to us Haida, so we can relate to it. It is no different from when

our grandparents inherited knowledge from their elders and gave meaning to that knowledge.

I want people to regard my work as universal. I want my images to have their own strength, so that a person does not have to have any knowledge about Northwest Coast art to appreciate them. When I look at a fine piece of sculpture from Japan or Bali, the meaning of that piece is not important to me, but I admire the quality and craftsmanship. The importance is the feelings that the artist has put into the piece, and those feelings vibrate out to the viewer. I want my creations to vibrate out to viewers and touch them. I want to bring viewers into that painting or that sculpture or that piece of jewellery. It excites me to present these pieces to shine forth.

I would like to offer my appreciation and gratitude to Ulli Steltzer for her patience in documenting these sculptures over the years; her wonderful photographs have given me another view of the projects. I am also grateful to Aldona Jonaitis for her contribution in shining another light on our recovery as a nation. And I would like to thank Saeko Usukawa for organizing the words to flow freely and in order.

– Robert Davidson

PHOTOGRAPHER'S NOTE

This is Robert Davidson's book. His art has inspired me over the last twenty years to spend many hours at his carving shed observing and photographing his work. The flow and power of his imagination as well as his never-ending drive to experiment with content, shapes and balance, continue to kindle my curiosity.

Photographing the subtlety of wood presents its challenges. The rough and contrasty surface of a mask or pole in its preliminary stages demands quite a different approach from the smooth satiny grain apparent in the finished piece. To do justice to these subtleties would require ideal light. In reality, however, in the carving shed and on the dance floors of Massett, light conditions – from the photographer's point of view – vary from being mediocre to outright adverse. Available light seemed to be my only option for capturing carvers and dancers who constantly move their positions.

The totem poles, lying flat on their back in the carving shed, made me often want to hang from the ceiling to get a better perception of what their final impact would be. How infinitely more demanding a task it must be to the artist to visualize the upright appearance of all those interrelating figures while chopping away at the log in its horizontal position. Of course, this is why Robert carves the small model poles. Even in their rough stage they serve as reference tools and often are finished only after the pole has been raised.

For this book I chose to concentrate on Robert's masks and poles. He is, of course, well known for magnificent work in silver and gold as well as for screenprints and painting, but black-and-white photography cannot convey the rich colours of the two-dimensional pieces and jewellery. Truly, I must confess that I am especially drawn to his work with wood. No photography can, in the end, do full justice to his work, but I hope that these photographs will serve as my tribute to a great artist.

I would like to thank Michael D. Poole for generously offering his photograph of the 1969 pole raising in Massett to be included in this book. My heartfelt appreciation and thanks to Robert's apprentices and assistants

(Reg Davidson, Chuck Heit, Glen Rabena and Larry Rosso) for their contribution to my often clumsy efforts to position myself to take photographs while they were carving. To Larry, special thanks for dancing five of Robert's masks outside the carving shed.

– Ulli Steltzer

INTRODUCTION

by Aldona Jonaitis

How do we understand art? On the most basic level, we understand art, a visual form of expression, by looking at it. Great works of art, such as Robert Davidson's carvings and prints, exude so striking an aura of refined skill coupled with a unique vision that virtually any eye can appreciate their excellence. But humans are verbal creatures; we use language to understand. So, to understand art, we read art history and criticism, listen to museum guides and, if lucky, hear the words of an artist explaining his work. At a symposium on Northwest Coast art at the American Museum of Natural History in October 1991, Robert Davidson stood before a large audience of artists, scholars and appreciators of First Nations art and presented a talk entitled "The World Is As Sharp As the Edge of a Knife."[1] While I sat and listened to this brilliant artist present an equally brilliant analysis of art, I realized how extraordinarily Davidson interwove art with words about art. Here was one of those rare artists like Piet Mondrian, Barnett Newman and Joseph Kosuth who could both create and speak about creativity.

In a remarkable prescient statement, Hermann Haeberlin, one of the great anthropologist Franz Boas's graduate students, wrote in 1918:

> The aesthetic study of our [Western] art is privileged by being able to become individualistic and biographical, so to say, thanks to the detailed documentary evidence bearing on its historical development . . . But in the study of primitive art it is just this biographical feature of the history of modern art that we need for stimulation.[2] We tend too much towards conceiving the art of a primitive people as a unit instead of considering the primitive artist as an individual. It is necessary to study how the individual artist solves specific problems of form relations, of the combination of features and of spatial compositions in order to understand what is typical of an art style.[3]

With this book of Robert Davidson's own words about himself, his training, his art and his life, we finally have the kind of individualistic and biographical document Haeberlin proposed more than three-quarters of a century ago. Davidson has been the subject of a good number of

publications which provide interesting insights into the man and the artist.[4] Even though Davidson's words inevitably appear, these publications remain the domain of their writers. In *Eagle Transforming,* Davidson's voice remains with us from beginning to end, forcefully and eloquently speaking for himself, authoritatively communicating his artistic visions. Most academic publications – valuable as they are – treat First Nations art from the perspective of an outsider. Here, in contrast, is an engaging, nuanced discussion of art from the perspective of the artist himself.

Although in recent years it has become the norm for First Nations people to assume a privileged position in representations of their heritage, Ulli Steltzer, whose photographs form the basis of this book, was far ahead of her time in that respect. For decades in her books of photographs on native people, she has insisted both on naming her subjects and having them speak for themselves about their culture, their traditions and their art. She has dedicated much of her professional life to documenting the life, work and art of Northwest Coast native people. Her sensitive studies of ninety-three artists in her outstanding *Indian Artists at Work,* her engaging photographic essay documenting Bill Reid's creation of *The Black Canoe,* the noteworthy *A Haida Potlatch* and her lovely portraits in *Coast of Many Faces* provide ample evidence that she is one of the pre-eminent North American photographers working today.[5] Indeed, O. J. Rothrock, Curator of the Graphic Arts Division at Princeton University, has put Steltzer's work "in the tradition of Jacob Riis, of Lewis Hine and Dorothea Lange," praising it for "its quality of direct engagement."

Ulli Steltzer's photographs vividly portray Robert Davidson's artistry with a keen eye and an unobtrusive presence, in images that could stand alone as a captivating record of the creative process. She shows us Davidson thoroughly engaged in carving his masks and totem poles, focussing intently. She shows him working with his associates, at times silently sharing the pleasure of their tasks, at times deep in conversation. She shows him, as well as his brother Reg, dancing at ceremonies that celebrate the dazzling vitality of a cultural tradition that refuses to die.

Steltzer's contribution to this book is even more profound than it appears to be from her photographs. Not only has she been documenting Robert Davidson and his work for the past twenty-five years but the concept of producing this book was hers, and she was the one who persuaded him to write the text for it himself. The resulting book is thus more than a documentation of artistic creativity, although it is certainly that. What the following images reveal is a synergistic collaboration between the artist and the photographer, based on decades of a long and productive relationship.

In this essay, I attempt to position Davidson's contributions to the literature on Northwest Coast art from three interconnected perspectives. I do not address Davidson's art per se – he does this himself, with great perceptivity. Instead, I offer first a brief historical survey of writings on Northwest Coast art to demonstrate why this book, written by a Haida about his own art, assumes so pivotal a position. Then I discuss the relationship this publication has to the large body of literature on style and meaning in Northwest Coast art. I conclude with some thoughts on Davidson's desire to transcend the limitations of externally imposed distinctions between Native and non-Native art. By associating formal, iconographic, biographic, historical and philosophical components in a seamless fashion, this book becomes a companion to a visual journey through Davidson's art.

NON-NATIVE VIEWS ON HAIDA ART

First Nations art has been the subject of a variety of evaluations by non-Natives. Some of the first non-Natives to visit Haida Gwaii in the eighteenth century, in search of sea otter pelts, spoke positively of the art they saw:

> Voyagers who have frequented the different parts of the Northwest Coast often saw there works of painting and sculpture in which the proportions were tolerably well observed, and the execution of which bespoke a taste and perfection which we do not expect to find in countries where the men seem still to have the appearance of savages. But what must astonish most . . . is to see painting everywhere, everywhere sculpture, among a nation of hunters.[6]

As long as their interactions were based on the fur trade, relatively cordial relationships could be maintained between the Haida and their visitors. However, by the end of the nineteenth century, First Nations people had become impediments to efforts to appropriate lands, as well as lost souls in need of salvation and religion. No longer the object of praise, their art came to be understood as embodiments of barbarity.

Turn-of-the-century anthropology provided scientific "evidence" for the supposedly inferior nature of Native people. According to the theory of social Darwinism, cultures assumed positions along a hierarchy of racial groups. Thus, the art of "primitive" people was less highly evolved and more backward than that found among the "civilized" races.

One anthropologist, Franz Boas, opposed this evolutionist notion, taking as his premise the intellectual and cultural equality of all peoples, regardless of race. Although he is best known for his writings on cultural anthropology, Boas used art as one significant indicator of this innate equality and wrote twenty articles on it.[7] His culminating statement on this subject, *Primitive Art,* begins:

> This book is an attempt to give an analytical description of the fundamental traits of primitive art. . . . [One of the principles] that should guide all investigations into the manifestations of life among primitive people [is] the fundamental sameness of mental processes in all races and in all cultural forms of the present day.[8]

Boas promoted ideas about the value of Native art, which for him embodied considerable intellectual sophistication. This assessment of Northwest Coast art – as well as all First Nations art – would ultimately become the rule rather than the exception.

One of the most frequently encountered stereotypes in the early literature on Northwest Coast art concerned the artist's supposed lack of individual creativity; the Native artist was thought to be a slavish follower of traditions, a copier of artistic conventions. It was among the Haida that Boas found Charles Edenshaw, an artist who would become among the first to dispel that notion. Edenshaw carved a set of model totem poles as

well as a model house, all of which ultimately became part of the American Museum of Natural History's Northwest Coast collection.[9]

Boas referred to Edenshaw by name five times in *Primitive Art;* his last reference describes the Haida master as "one of the best artists" of that group.[10] By referring to Edenshaw by name, Boas differed from most others who described the "primitive" artist as anonymous, tradition-bound and conservative. The artist with a name assumes the status of a "fine artist," whereas the nameless one usually receives the designation "craftsperson."

Except for Boas's references to Edenshaw, few scholars named individual artists until 1944, when Marius Barbeau published an essay on Edenshaw's carvings.[11] From then on, signature styles of individuals became evident, thanks to the meticulous scholarship of Steve Brown, Wilson Duff, Bill Holm, Peter Macnair and Robin Wright, to name just a few.[12]

Another misconception about northern Northwest Coast art that has achieved a certain prominence concerns its "disappearance." According to this version of art history, some time between 1890 and 1920, the Haida, Tsimshian and Tlingit ceased making the refined, elegant art characteristic of the mid-nineteenth century. Museum anthropologists (including Franz Boas) collected Native artifacts so that future generations would be able to study the cultures of these "vanished" people.[13] As a result, museums possess immense quantities of art removed during these "salvage" operations.

Many scholars agree that up until Edenshaw's death in 1924, some attractive argillite carvings created intentionally for sale to outsiders were produced; afterwards, however, the art slid downhill until it was a "shadow" of the glorious earlier style.[14] In museum collections, artworks turned into artifacts that served as indicators of vanished cultures. It was an irony of history that most scholars dismissed the sculptures, paintings and textiles made subsequent to the "golden age" of Northwest Coast art as being far cruder as well as less genuinely "Native" than their more refined, decidedly more "authentic" prototypes.

The non-Native privileging of the past and the denial of twentieth-century expressions of continuity and endurance provided the context for the northern Northwest Coast artistic "renaissance" that began in the

1960s. During this time Bill Holm identified the formline system as the canon of the northern Northwest Coast style, and Bill Reid began carving in the manner of his Haida ancestors.[15] These two men, in addition to Wilson Duff and Doug Cranmer, exerted considerable influence on Davidson. However, as Davidson makes clear, others in Haida Gwaii influenced him as well.

These carvers made artworks that inspired within Davidson an initial artistic vision that made him receptive to the masterworks he saw in Vancouver. Had he not started carving in Massett in the presence of living artists, he might never have been drawn to study the art of his ancestors in museums. Indeed, Robert Davidson stands as a most compelling example of how Haida culture was not lost, despite all accounts that it had disappeared. We might even say that the spirit of his ancestors, including Charles Edenshaw, inspired him prior to his epiphany at the Vancouver Museum and the University of British Columbia Museum of Anthropology. As this book makes clear, the history of Northwest Coast art must be modified to include a much more sophisticated understanding of artistic continuities such as those present on Haida Gwaii in the twentieth century.[16]

The history of literature on Northwest Coast art starts with favourable accounts of eighteenth-century voyagers, changes to negative assessments from those who viewed Natives as impediments to progress, becomes more accepting of cultural differences with Franz Boas, mourns the disappearance of the "authentic Indian" and arrives at the present acceptance of varied expressions of cultural endurance. One feature connects the representation covered thus far: all have been produced by Euro-Americans. Within the past several years, anthropology has come to recognize how profoundly the process of ethnographic representation magnifies the asymmetrical power relations between representer and represented.

One way anthropologists have attempted to counteract this is by providing space for the voices of the represented to speak without a scholarly filter. Another way to demolish power asymmetries is for Native people to assume the authority to speak for themselves. In this publication,

Robert Davidson does just that. Indeed, *Eagle Transforming* represents a significant departure from all other works on Northwest Coast art, as Davidson offers penetrating insights into the style and the subject matter of his creations while providing intimate glimpses into his artistic development. No future publication on any theme of Northwest Coast art will be able to ignore this historic work that not only features the art of an individual but is written from the most unquestionably authoritative position: the first person.

STYLE AND ICONOGRAPHY

Davidson offers fascinating insights into the process of creating contemporary Haida art, challenging us to understand more deeply the complexity of its form. As such, he is the most recent, and in some ways the most successful, in a long line of individuals who have analysed this style. In 1897, Boas published "The Decorative Art of the Indians of the North Pacific Coast," in which he tried to interpret the complex imagery of the northern two-dimensional style.[17] As early as 1918, Boas's student Hermann Haeberlin posed questions about Northwest Coast art that went beyond his mentor's analyses. For example, he asked what relationship existed between design elements within the same depiction, such as eyes and brows, and wondered about "the persistency with which painted lines are given artistic 'character' by making them lighter and heavier at different points, as for instance in the outlines of the eyes which represent joints."[18] Haeberlin died before his essay was published, so his legacy lies in the questions he posed, not his answers.

These answers had to wait until 1965, when Bill Holm published his classic *Northwest Coast Indian Art: An Analysis of Form* and defined the formline, "the characteristic swelling and diminishing linelike figure delineating design units. These formlines merge and divide to make a continuous flowing grid over the whole decorated area, establishing the principal forms of the design."[19] Holm also named other design elements found in the northern style – ovoids, U-forms, split-U forms – and by so doing established a valuable vocabulary for discussing this style. As Holm

was analysing form, Bill Reid was studying artworks in museums and trying to replicate old objects in order to identify the underlying principles of Northwest Coast art.

Davidson offers explications of his work within the formline tradition as understood by Reid and Holm, as well as sensitive statements that reveal how far he has gone beyond the previous understanding of that tradition. In *Northwest Coast Indian Art,* Holm describes the ineffable quality of great art within this or any other tradition:

> As in all art it remained for the imagination and sensitivity of some of the most imaginative and sensitive of men to give life to a list of rules and principles and produce the wonderful compositions that came from the Northwest Coast. It is precisely because each piece was the creation of the mind of a man that it can be analyzed only superficially in terms of elements and principles, while the quality which raises the best of Northwest Coast design to the status of art remains unmeasured.[20]

I suspect no one would disagree that these words accurately describe Robert Davidson's artistic achievements.

In addition to providing insights into style, Davidson describes how his art achieves meaning. The study of iconography, like that of form, has a history that goes back to Boas. In his initial investigations of Northwest Coast art, Franz Boas tried to enumerate the characteristics that identified specific animal subjects; thus the beaver had large incisors and held a stick in its forepaws, while the killer whale had a large dorsal fin and a blowhole. Unfortunately, his attempts to clarify the visual vocabulary left Boas vulnerable to criticism that he formulated a rigid iconographic canon that denied the complexity of multiple meanings so fundamental to a rich artistic tradition.

In 1943, the great French anthropologist Claude Levi-Strauss wrote "Art of the Northwest Coast at the American Museum of Natural History," taking the outstanding collection of that New York City museum as his inspiration for an investigation of the deeper meanings hidden within the carvings and paintings.[21] In the years since then, books and articles

purporting to explain the iconographic complexities of Northwest Coast art have appeared regularly.

These scholarly investigations of Northwest Coast iconography are too numerous to discuss here, but it is important to note that virtually every one of them has been written by non-Natives. Although it is not my intention to suggest only Native people can interpret their own culture, investigators who try to enter the world view of a people by means of their art or by means of their art coupled with their mythology, without seeking contributions from the people whose culture they analyse, limit their projects considerably.[22]

In this book, Davidson transcends this unfortunate chasm between the representers and the represented because he can speak about the meaning of his art from two perspectives: one coming out of his experiences of having been raised Haida, the other from his comfortable membership in the international art community. His philosophical inquiries into the creation and communication of meaning enrich this book enormously.

TRANSCENDING THE ETHNOGRAPHIC SPECIMEN AND BECOMING ART

The history and importance of Robert Davidson's work has another dimension: its prominence within the international art world. In his preface, Davidson says, "I really believe that our artform fits in with all the other categories of great art."

Up until quite recently, many studies of Northwest Coast art have accepted as a given its position within the "primitive," the "aboriginal" or the "First Nations" spheres. It has taken First Nations art a long time to emerge out of the confining position of "ethnographic artifact" or even "ethnographic art." The first major breakthrough occurred in 1941, when the Museum of Modern Art in New York filled all four floors of its building with an extraordinary display of Native art, including an entire section devoted to the Northwest Coast. At about the same time, European artists taking sanctuary in America from World War II "discovered" Northwest Coast art. Their celebration of this style as an artform to be admired,

coupled with the similar evaluation by the early Abstract Expressionists in the 1950s, contributed to a new appreciation of it. Then, in 1967, the Vancouver Art Gallery presented a sensational exhibit, "Arts of the Raven," organized by Wilson Duff, Bill Holm and Bill Reid. This historic show finally situated Northwest Coast art as a style to be taken seriously as art.

Davidson's assertion of his art's equality with that of other traditions raises interesting issues about the nature of contemporary art and its evaluation by critics. Certain features of contemporary intellectual culture, specifically the relationship of modernism and postmodernism to art, present intriguing insights into the position of Davidson's art. Postmodernism denies any text that is based, either consciously or unconsciously, upon hierarchies of race, colour or class. It questions, and demonstrates as arbitrary, canons which have traditionally determined excellence. One ultimate goal of postmodernism is to provide space for previously ignored or even stifled expressions and to recognize the merits of things previously dismissed. Postmodernism thus provides an intellectual framework for Davidson's acceptance as a great contemporary artist.

By its very name, postmodernism responds to certain tenets of modernism. Much art history and art criticism, from the nineteenth century until quite recently, was based upon the positive evaluation of modernism which, simply put, studies and celebrates art that is innovative, different from what preceded it, and rebels against its roots by introducing new formal elements. It is an interesting irony of history that the modernist tradition was in part responsible for excluding art such as Davidson's from acceptance beyond the Native sphere. For the modernist, any contemporary Native art that adheres to a tradition might be interesting as anthropology, but would not be acceptable in the international art world because of its lack of genuine rebelliousness and its foundation in an old style and iconography. This kind of evaluation may in part be responsible for the relative rarity of contemporary Northwest Coast art in fine art collections.

Davidson's connection to tradition and innovation beyond that same tradition reveals an inherent contradiction within modernism that postmodernism resolves. We can compare the aspects of his work that

prevented modernists from accepting contemporary Northwest Coast art with those that prevented some anthropologists and ethnographic art historians from considering it genuine and authentic. Those who firmly believed in the enduring value of artistic traditions could reject contemporary Northwest Coast art as not being fully grounded in traditional ceremony and social or religious life, as accepting new media like serigraphy, and as inventing new forms and new symbols. We might say they adhere to a "purity paradigm" and forget that the sign of a living culture is its transformations, not its classicisms. Modernists dismissed contemporary Native art because of its connection to tradition; ethnographic purists dismissed it because those connections were too weak.

Robert Davidson's outstanding one-person retrospective was a critical success both at the Vancouver Art Gallery (1993) and at the Canadian Museum of Civilization in Hull (1994). Here is a final resolution of the contradictions inherent in the old modernist and anthropological paradigms. Finally, the anthropological community has acknowledged and celebrated innovation as well as persistence, while the art community has recognized that creativity takes many forms. In this book, we come to understand in greater depth the outstanding genius of a great contemporary artist.

Chapter One

BEING HAIDA

We call ourselves *xaa.aadaa 7laaisiss,* "the good people." The name commonly used now is Haida. We are the survivors of a once proud, prosperous and productive nation who enjoyed the fruits and beauty of these islands we call Haida Gwaii and which you call the Queen Charlotte Islands. Our way was to be generous and hospitable to visitors, especially those European explorers and traders whom we came to call *yaats xaa.adee,* "the iron people," for the iron they traded to us in return for furs. After the arrival of Europeans in the late eighteenth century, we suffered great losses in population, cultural knowledge, and most of all self-esteem, self-worth and identity. We lost a link in the chain of our development as a nation; a whole generation was denied its own cultural values.

In the 1060s, the European diseases of smallpox and measles decimated the Haida population, leaving, at its darkest period, only five per cent of the people alive. The survivors carried on despite the incredible loss. One of them was my grandmother's mother, who was only four years old in 1862, the year most of her family died of smallpox. When I was little, Naanii (Grandmother) used to tell me the story of how her mother had been saved by her uncles.

Missionaries first came to the village of Massett in 1877. (I prefer to use the original spelling of Massett; the post office dropped one *t* because of possible confusion with Merritt.) They arrived with the aim of transforming the "primitive" people (us) into "civilized" people (them). In doing so, they totally disregarded a way of life that had been established for many centuries. Our songs, dances and ceremonies were a threat to the missionary way of thinking, so they discouraged us from continuing our way of life. Our totem poles were chopped down and left to rot or used for kindling; many were sold to museums. The missionaries asked the Haida people not to carve them any more, not to raise them any more. We were made to believe this was a heathen act. (Now, I know, they have changed their views and are supporting us in reclaiming our cultural values.)

In 1880, an amendment made by the Canadian government to the Indian Act made it a criminal offence to participate in the potlatch, our most important ceremony. The potlatch is a public forum where a chief or a clan

lays claim to positions; where people lay claim to the ownership of crests, songs and dances, the ownership of property, the ownership of names. Names are very important pieces of property that carry responsibilities and privileges; some carry ownership to lands. Names belong to families and can only be handed down through the rightful lineage (in our case through our mothers, since we are a matrilineal society).

To further weaken the spirit of the Haida people, the children were taken away by the government to residential missionary schools far away in the south. As children, my parents' generation were not allowed to speak their own language and were punished if they did. In many cases they were not allowed to visit their homes even in the summer, and some did not see their parents for years. When they were finally allowed to return home, they were strangers in their own homeland. Some became permanently scarred psychologically. They had left as Haida people and came back as people with no identity.

Naanii, Florence Edenshaw Davidson, said to me, "We didn't want you to go through the same thing that my children went through, so we didn't speak Haida to you." As a result, my generation was brought up not speaking Haida. Language holds the insights and beliefs of our culture. Language holds the key to many ideas that we do not have access to by speaking English.

When I was a child, I was ashamed to be Haida, like many of my friends. This came from our parents' lack of self-esteem and self-worth, their language and beliefs having been beaten out of them in the residential schools. These same feelings were handed down to us.

One of my favourite stories is about watching cowboy and Indian movies. My friends and I would cheer on the cowboys because we knew the Indians lost 99 per cent of time, and we didn't want to be losers. When my uncle pulled me aside and told me that I was Indian, I just cried in disbelief.

We have lived under British colonial administration and then the Canadian system since the 1860s. My surname, Davidson, only goes back to my grandfather, Robert Davidson Sr. I am only the third generation to have that surname. My grandmother's surname, Edenshaw, goes back only

four generations, to her uncle Albert Edenshaw. Edenshaw is derived from the Haida chief's name 7idansuu. When my grandmother's parents were married in church, the missionary gave them, as their surname, her father's chief's name 7idansuu, which has become Edenshaw. According to the British system, his wife was given his surname, but she did not want to accept it. She said, "How can a Raven woman have an Eagle name?" She was from the Raven clan and her husband was from the Eagle clan. There are many similar stories of how there was confusion when the British and Haida cultures met. We have two main clans, Eagle and Raven. Those are also the two main crests, though each clan owns many more crests. When we marry, we must marry someone from the opposite clan. Today we are still strongly influenced by British ways, which causes much confusion over inheritance. We use our father's surname, but it is our custom to follow our mother's lineage and belong to her clan.

The missionaries and the government tried to change the Haida without trying to understand who we were. But that our art intrigued the white man is evident from the great collections housed in museums around the world. Each piece preserved in these museums is a document of our once rich culture. When you look at each masterpiece, you can see that it crystallizes all the experience of the artist who made it. It is a documentation of the time in which he lived.

Since the almost complete destruction of our spirit, our disconnection from our values and beliefs, it has been the art that has brought us back to our roots.

Chapter 2

BECOMING AN ARTIST

My interest in Haida art began when I was very young, watching my father carve wood, my grandfather carve argillite. Argillite is a soft black shale found only in Haida Gwaii. When I was growing up in Massett, many carvers were creating objects for sale to the tourist market.

My father, Claude Davidson, was a carpenter and a fisherman; he started carving model totem poles in wood when I was ten or eleven years old. I remember him starting one carving that was beautiful; it still has a good presence when I look at it now. And then he began carving in argillite.

I spent a lot of time with Tsinii (Grandfather), Robert Davidson Sr., fishing for halibut and salmon. It was on those trips with Tsinii, listening to him talk, that I got a lot of my beliefs and ideas. He started carving in his late fifties or early sixties. Before that he was a canoe maker, boat builder, carpenter and fisherman. I find that inspiring, to start another profession so late in life.

Charles Edenshaw, one of the great Haida artists, was my grandmother's father. The family didn't talk about him very much, but Tsinii had made boxes for Charles Edenshaw to paint and carve. In 1908, Tsinii and his brother, whose name was T'aak, carved a 60-foot canoe that Charles Edenshaw painted.

When I was thirteen, my father insisted that I start learning to carve. He didn't ask me if I wanted to start carving, he insisted that I start. I had a real feeling of déjà-vu, that I'd carved before in another lifetime.

To teach me, my father carved one side of a model totem pole in wood. My job was carve the other side to match up what he'd carved. The learning process that an apprentice goes through is to copy another person's style. Because I learned by copying totem poles that Tsinii or Dad had carved, mine were actually copies of copies – they were third-generation carvings. Dad and Tsinii, like the other carvers in Massett in the late 1950s and early 1960s, were inspired by fuzzy photographs of argillite carvings in three books written by Marius Barbeau and published by the National Museum of Canada: *Haida Carvers in Argillite, Haida Myths* and *Medicine Men.* He helped to inspire some carvers to start carving argillite by coming out with those books.

I'd carved two model poles in wood, when one day a lady from Skidegate, Mildred Pollard, was visiting my grandparents. It was rare at that time for a woman to be carving, but she carved argillite in the back of the truck wherever she and her husband were travelling, and she showed us her newest little totem pole. My dad said, "Oh, wow, you should start on something like that too." He cut me out a piece of argillite, a three-inch piece, and that's how I started in argillite. I made three- and four-inch high argillite totem poles for many months and eventually made bigger models. They were all copies from the Barbeau books. All the carvers had their favourite photographs in the books, and you could tell which they were since those pages were the dirtiest from the black argillite dust. It was interesting to see how each person interpreted the same photograph; each one saw something different.

After carving in my dad's style and working with him for a while, I began to work with Tsinii. I preferred Tsinii's style. It was a little more advanced and he had a little more experience. I remember one time I'd worked really hard on the Eagle at the top of a pole; I sanded it smooth, made it shiny. I was really proud of it and showed it to my grandfather. Without saying anything, he started to carve it. I was absolutely devastated. I stood there in anger and frustration because I thought I'd finished it. But when he was through, there was an incredible improvement.

I also spent a lot of time visiting other carvers in Massett to look at their workshops, their tools, their carvings. I was curious and had a real craving to see what they were doing. When people said what a great carver Pat McGuire was, I wanted to know what made him great. There were many carvers who kept the art alive through the rough times, such as Moses Ingram, Robert Davidson Sr., Robert Collison, Art Adams, Louis Collison, John Marks, Robert Ridley, Henry Moody, Rufus Moody, Charles Gladstone, Tom Hans, Andrew Brown, John Cross, to name a few.

A couple in New Massett owned an argillite totem pole by John Marks, a carver from the 1920s to the '40s. This was a rare discovery, because there were hardly any old carvings around. The high quality made me wonder how such a fine piece of work could be executed.

At this time, the art was at a low ebb. There was no evidence anywhere in the village of the once great culture that I came from. All we had were photographs. Many things, boxes and masks and rattles and drums, had been lost in house fires over the years. Some things had been left in abandoned villages after the epidemics and the people's embrace of the new white culture. Other things had been either stolen or bought by museums. Finally, there was less artistic activity, so nothing had been made to replace what was lost.

There were no totem poles left in Massett, absolutely none. The only poles I saw were in Yan, an abandoned village across the inlet. They were pretty weathered, and they weren't part of our upbringing. I didn't realize how close I was to them; when my grandparents were children, those totem poles were new. It wasn't until I left home and went to Vancouver that I saw the variety and the incredibly high level of art that my ancestors had achieved.

I left Massett in 1965 to finish high school in Vancouver. My parent's generation could not go beyond grade eight, according to the law. My generation was able to go to high school, but then the school board dropped grades eleven and twelve from the high school in Massett, which meant that we had to leave home if we wanted to finish high school.

While I was going to school in Vancouver, I kept carving model argillite poles to earn pocket money. The fact that I became an artist wasn't because it was my desire, but because it seemed like all the roads were leading me that way.

The students at my new school were curious about who I was and where I came from. "What is it to be Haida?" This was the big question. I didn't know. Then I started to go to museums and saw for the first time art done by my ancestors, art beyond my wildest dreams, art I did not understand, art whose purpose I did not know. I discovered that there was more than argillite totem poles. There were carved rattles, carved bowls, carved speaker staffs, carved paddles, carved and painted canoes. I saw photographs of ancient Haida villages, with many totem poles lining the fronts of the villages.

I was in dreamland, I was in the spirit world, images were alive. It was another déjà-vu experience. I felt that I had been there before. These images made me hungry. I wanted to learn more about them, what they meant and what they represented. I spent many hours studying these new-found treasures, these masterpieces, and they still influence my work today.

The museums opened my eyes. It was exciting to see what a high standard could be achieved with the Haida artform, and it challenged me to raise my own standards. Those objects in the museums were all that survived the incredible change my ancestors had experienced. A lot of the songs and dances had died; they're more ephemeral than visual art. The art, on the other hand, was saved and housed in museums.

I went to look at the totem poles that Bill Reid had carved at the Haida replica village at the University of British Columbia and the poles in the museums, but I didn't grasp what they meant or what their function was until much later, after I actually carved one.

When I began studying the carvings in the museums, I didn't really know what I was looking at. All I knew was that it was a really fine and high and sophisticated artform. Fortunately, several people had analysed Northwest Coast art in the 1950s. One was Bill Holm, a museum curator; another was Wilson Duff, an anthropologist, and a third was the Haida artist Bill Reid. They and other people like Doug Cranmer, a Kwakwaka'wakw carver, helped me to look at the art in a new way.

I still remember the day when Doug Cranmer showed me how the ovoid shape was drawn. It looks like an oval, slightly flattened or concave on one side; the corners on the bottom are sharper than the upper corners. I was absolutely flabbergasted. I went to the University of British Columbia to look at the old boxes to confirm this new information about how the ovoids were shaped.

The ovoid was my connection on how to stylize and formalize the artform. Before that, I'd only used the ovoid very loosely. It wasn't even understood by my dad or *tsinii*. We were just copying from the Barbeau books. It was like trying to write by copying, mimicking, but without knowing the alphabet.

I met Bill Reid when I was still in high school and was demonstrating carving in Eaton's department store to earn some money. After finishing high school, I apprenticed with him for about a year and a half. He taught me a lot about form and design, about composition, and about Northwest Coast art.

Like my *tsinii* and dad, Bill stressed the need to maintain high standards of quality. The shopkeepers who bought my argillite pieces also demanded quality. I remember the feeling of fear when I walked into the Hudson's Bay department store in Vancouver to sell my argillite carvings in 1963. And the feeling of relief when the buyer said they would take the model poles if I made them smoother. I went back home, worked on those carvings to make them more presentable, of acceptable quality, and returned to the store. He bought them. I wonder where he is now. I'd like to thank him for having the strength to maintain his standards.

After I started studying with Bill, there was a great improvement in my argillite carving. I also learned how to work with silver and gold, making jewellery. He gave me a lot of guidance. I copied his style until he said it was time for me to do my own design for a bracelet. He stuck me in a room and took everything away, all the photographs, all the books, and told me to create my own bracelet design. I did several. He said they weren't good enough. I was at the drawing board for four days before he finally approved a design and allowed me to engrave it on a bracelet.

Bill Reid strongly recommended that I go to art school to learn how to draw. He said that if you could learn to draw, then you could do almost anything. It's the best advice he ever gave me. Drawing enables me to capture the images that flash through my mind.

At the Vancouver School of Art, which is now the Emily Carr College of Art and Design, I studied drawing, design, sculpture, painting and pottery.

Whenever I came back home to Massett on visits, I felt really saddened by the lack of art in the village. After Doug Cranmer taught me about the ovoid, I was so excited that the next time I went home I literally knocked on every door in the village to hunt down any artifacts, anything connected to the old artform that showed those ovoid shapes. There were two boxes. That was it.

THE *BEAR MOTHER* POLE IN MASSETT, 1969

The inspiration that drove me to carve my first totem pole came when I was making my rounds at Massett, visiting the elders with whom I'd made friends over the years. At one home, to my surprise, there was a group of elders in the living room. It turned out they were holding a prayer meeting. Their own ways had been taken away from them, and all they had was a prayer meeting, a way that was foreign to them. All the meaning in their lives had been taken away from them – their identity, culture and beliefs – and been replaced by Christian ideals.

This moment moved me so much that I wanted to create an occasion for my elders to celebrate one more time in a way that they knew how. The totem pole was the first image that came to my mind. I wanted a totem pole for the village because they didn't have any at all. I wanted to carve a totem pole so that these people would shine one more time.

Prior to this experience, I was living in *yahgu naas,* or "the middle house." I was suspended in midair between two cultures, Haida and the white man's. In committing myself to carving the totem pole, I was moving into the circle of Haida knowledge.

Many people helped me to complete the dream of carving a pole. Audrey Hawthorn, who was then the curator of the Museum of Anthropology in Vancouver, got a cultural grant of $3,000 from the government to help fund the project. My grandparents gave me a lot of moral support. My dad walked through the woods for two weeks, searching for a log for the totem pole, and found one with only six or seven knots on it. I decided to carve a 40-foot totem pole.

I hadn't worked on anything that big before. I still remember the day I drove to my parents' house to start the project. It took all my nerve to go and look at the log. When I saw the log, it was huge. I said, "Holy shit, what did I get myself into?" Those were my exact words. I didn't know anything about how to move the log, I didn't know anything about how to straighten the log or prepare it for a totem pole; all I had was ideas and energy. I was twenty-two years old when I carved that totem pole.

The story the pole depicts is a Tsimshian legend, though it is also told by the Haida. The story is quite long and involved, but the gist of it is that the chief's daughter and her companions were out picking berries, when the chief's daughter accidentally stepped in some bear manure. She made fun of the bear for leaving its droppings just anywhere, and the bear people heard her. When she became separated from her companions, the bear people kidnapped her and took her to their village. She eventually married one of the bear men and gave birth to two cubs.

At that time I didn't have very much cultural knowledge, but I wanted this to be a neutral totem pole for the whole village. Now, I know that it's a Raven clan pole, since the Grizzly Bear, the main character of this pole, is a crest of the Raven clan. The only way it could have been neutral was to have crests from both Eagle and Raven clans on there.

I started carving in May 1969, which is the time when we go to the Yakoun River to get our winter supply of fish. Tsinii was eighty-nine and almost blind, so I spent many nights after working on the pole helping him and Naanii at the fish camp. There was some resistance to the idea of the pole because of the Christian values ingrained in people; some of them were against going back to these heathen carvings. But Tsinii said, "You're doing a great thing." It inspired me that he cared so much.

The work on the pole took three and a half months to complete with the help of my brother Reg, who was fourteen. That was his first time carving.

My grandparents' generation had only heard stories about the proper way to raise a totem pole, but they knew there was a protocol to it, that certain ceremonies had to be done. When you create an occasion like a totem-pole raising, it sparks memories; people remembered more and more details about what they'd been told about raising totem poles. The elders became excited: they started singing songs, they started dancing a few dances that they knew. About two weeks before the pole was to go up, Tsinii told me that I, as the carver, had to tie all my carving tools around my neck, then chant and dance around the pole before it was raised.

I didn't understand what a powerful symbol the pole was until the day came to raise it. It was like the birth of a child. Just as no one but the parents

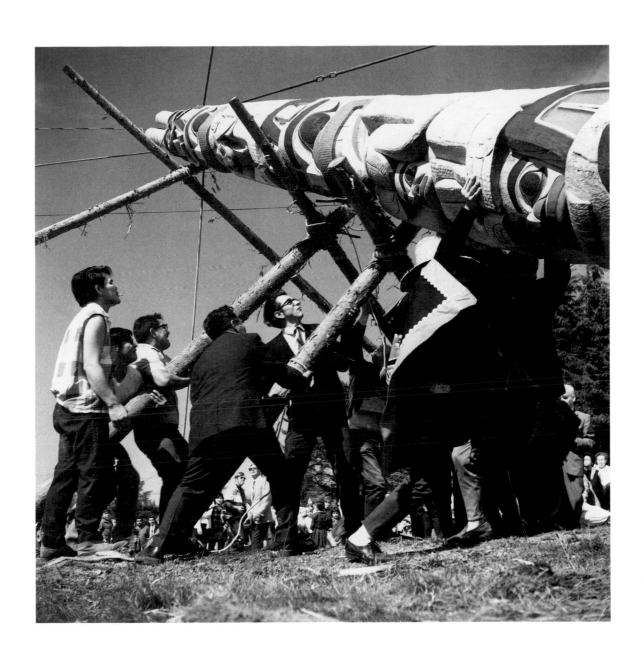

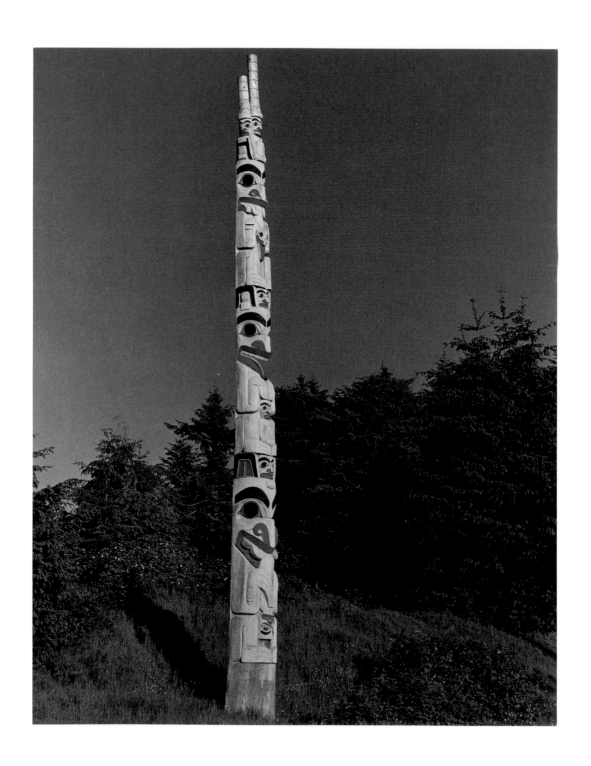

really knows about the pregnancy period, no one cared about the actual carving process. But when the time came for the pole to be raised, everybody was present. They wanted to be there to witness that moment. There was not one person living in the village who had witnessed a pole raising.

The ceremonies were directed by Tsinii. My aunt told me that after the totem pole was raised, she saw him lying on the couch and breathing a sigh of relief: "My job is finished now because I've witnessed my grandson raising a totem pole." He died about three weeks later.

When the totem pole finally stood up in the air, I realized what was really happening. It was the reawakening of our souls, our spirits. It was the reconnection with the values that still existed, with some of the innate knowledge that was demonstrated on that day. There is a lot of knowledge that can only be expressed in terms of ceremony. The totem pole became the medium through which to transfer that knowledge, knowledge that you cannot get out of a person by interviews.

The totem pole caused an incredible change in my life, in my understanding of ceremony, of what art means to the people.

CARVING POLES IN DUBLIN AND MONTREAL, 1970

The World Council of Craftsmen had a conference in Dublin in 1970, and I was invited to demonstrate carving a totem pole there. That same year, I also demonstrated carving in Montreal for "Man and His World" at the site where Expo '67 had been held. The Museum of Anthropology at the University of British Columbia was displaying its collection at "Man and His World," and part of that was to have myself and Bill Reid demonstrate carving. The pole I worked on was the same size as the one in Dublin, both being ten feet tall.

On the Dublin pole, I carved Raven with the face of a Human on the bottom, where the Raven's body joins the tail feathers. The top figure between the ears of Raven is a Frog. I was copying someone else's style of rendering Raven on a totem pole.

Facing page: *The Bear Mother pole: "At the bottom is the Bear Father holding an upside-down cub, whose legs are in his mouth. Between the ears of the Bear Father is another cub, and above them is the Bear Mother holding a third cub, with a fourth cub between her ears. Above them is a third Bear with a Frog. At the very top are the Three Watchmen."*

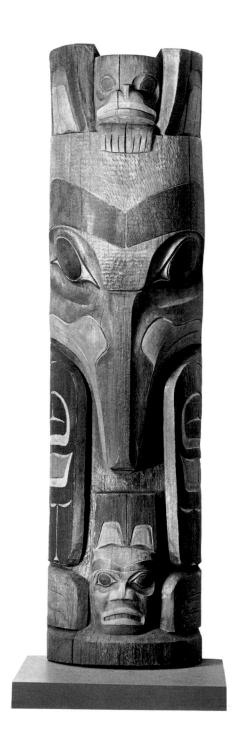

EARLY MASKS, 1960 TO 1981

The very first Haida ceremonial mask that I saw being used was a brown paper bag during one of the dance practices for the raising of my first totem pole in Massett in 1969. Naanii was doing what we call a K'awhlaa, a spirit dance. She felt awkward without a mask to wear, so she asked someone to get her a brown paper bag from the kitchen. She cut eye holes in the bag, put it over her head and did the dance. I call that time period the brown paper bag era. This challenged me to carve a mask.

I'd only seen masks in books. I may have seen masks in museums, but if I did, I don't recall doing so. I started to carve a mask for Naanii, but because I didn't have any knowledge about masks or mask-making, I carved it in secrecy. I was too insecure to show it to her or anybody else, so it was never used. (Ten years later, I carved another mask for the very same spirit dance, and that mask was danced. It had no resemblance to the first mask I'd made.)

After the pole raising at Massett, I carved a lot of masks, mostly portrait masks except for the odd Dogfish mask or Eagle or Grizzly Bear. My early masks were very simple, and I copied a lot of masks; they were meant mainly to be hung on a wall rather than danced. They didn't have the depth of the masks I make now. You can really see the difference between the masks I carved before I started singing and dancing, and the masks I made after I started singing and dancing.

Often I'm blindly and intuitively collecting pieces of information. I feel that I'm putting a puzzle back together, but I don't know what the puzzle is. For example, the first mask I made to be danced was K'awhlaa. One of the elders came up and said, "That mask has eagle feathers on it." So I put eagle feathers on it. The more we danced with these masks, the more details the elders remembered. Some were reluctant to give us information. One person said, "Why do you want to go back to those old ways?" There was a lot of pain, a lot of tears being stirred up again.

Once I became confident making masks, the masks led me into ceremony, the very sacred part of being Haida or of being human. When I started to sing Haida songs and do the dances, when I started to be

Facing page: *The 10-foot pole Robert carved for Dublin, Ireland, in 1970.*

27

involved in ceremony around 1976 and 1977, I realized that was where the art came from and that was where it belonged. It gave the art a whole new meaning for me.

The inspiration for masks comes from many different sources. When I first started to sing, I tried to imagine the mask that would go with a song. In 1980, at a celebration called "Tribute to the Living Haida" that I hosted in Massett, people from Hydaburg, Alaska (just over the strait from Massett), sang a Dogfish song and danced. I loved the song. It was exciting – for the first time, I could put a song to the many Shark and Dogfish masks I had carved. I traded them a song for the Dogfish song, so that we could use it, and carved several new Dogfish masks for that dance. The Dogfish has incredible features, and it's a challenge to create something unique because it's been so well explored by other artists.

One time, doing the spirit dance and song, I asked Naanii, "How does the mask look?" She said, "Just make it smile," only the word *7eeyaa* in the song means "I'm in awe." Then I started to understand the freedom one has in expressing these dances. The art actually had more freedom than I'd been led to believe by anthropologists – with all due respect to anthropologists, many of whom became good friends. Anthropological knowledge and actual experience are two different things.

After that, the more we sang and the more we danced, the more confident we became, and the more comfortable we were taking part in ceremony.

THE CHARLES EDENSHAW MEMORIAL LONGHOUSE, 1977

In 1977, Parks Canada approached me on the recommendation of George MacDonald of the National Museum of Man (now the Canadian Museum of Civilization). They wanted to create a monument to honour Charles Edenshaw for his contribution to the arts in Canada. This was one of the first big jobs for me. At that time I was only working on masks, jewellery and prints. It so happened that people in Massett were building a traditional Haida house, and I suggested that I carve the front of it as the monument. I made that proposal and they agreed with it.

Since this was a memorial to Charles Edenshaw, I looked at everything of his that I could find and decided to adapt a Frog design that he had used on a chief's seat. I chose Frog because that was one of his main crests. After I adapted the chief's seat design to the shape of the front of the house and to its much larger scale, two apprentices – Reg Davidson and Gerry Marks – helped me to carve and paint it.

When Reg, Gerry and I were close to finishing the housefront, we were visited by Joe David and Beau Dick. Joe sang a song to us and the carving. It was a powerful moment, again connecting art with ceremony.

We spent two years on the longhouse. The second year, we carved the four house posts for the inside. I decided on two pairs of totem poles, two in the front, two in the back. One pair was to represent the Eagle clan and other pair the Raven clan. There were eight apprentices: Alfred Adams, Reg Davidson, Jim Hart, Don Yeomans, Paul White, Dickie Bedard, Mike Nicoll and Earl Jones. Two of them worked on each pole, and the work took six months.

A few years later, in 1981, the Edenshaw Memorial Longhouse burned to the ground. I came home and sang a crying song, and the image of a black frog came to me, a frog because I had carved a Frog design on the housefront and black to symbolize that it had burned. I asked Reg to carve a black Frog mask, and he danced it at the potlatch "Children of the Good People" that I hosted later that year. After the black *Frog* mask was danced, we threw it into the bonfire to signify the end of mourning for the longhouse. To balance the black Frog mask, we danced the red *Eagle Spirit* mask.

The *Eagle Spirit* mask is also a very powerful image, though when I carved it, it had no function or purpose. In fact, it was so powerful that I was afraid of it and had hidden it away for a year, showing it only to trusted friends. When the *Eagle Spirit* mask was given birth that evening, it symbolized the love we are regaining for ourselves and the strength we are gaining as a people, the strength we need to reclaim our position in the world.

Robert Davidson working on a Frog mask, 1974.

Robert carving a portrait mask in his Whonnock studio, 1975.

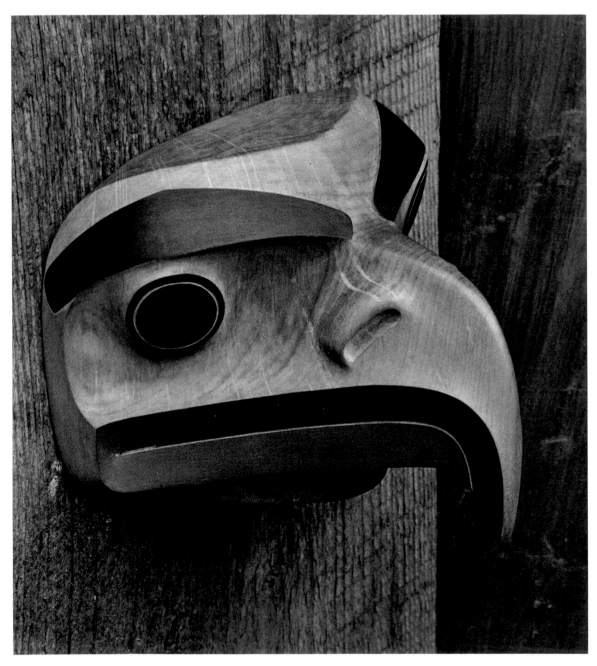

Eagle *headpiece, alder, carved in 1976; it belonged to the late Chief Gaalaa.*

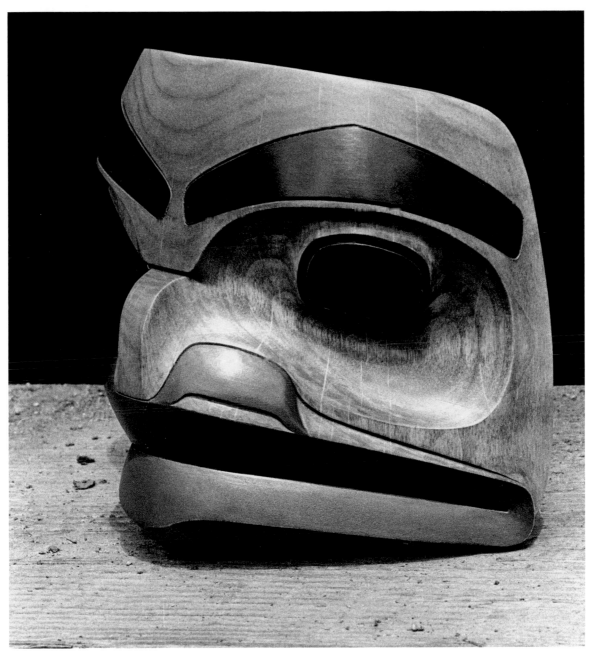

Frog *mask, alder, carved in 1976 (the same mask is shown being carved earlier in the book).*

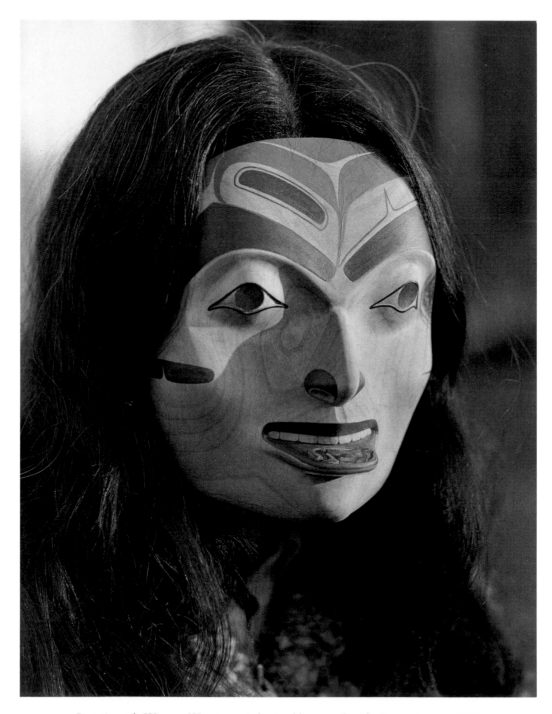

Portrait mask, Woman Wearing a Labret, *alder, worn here by Doreen Jensen, 1975.*

⋮

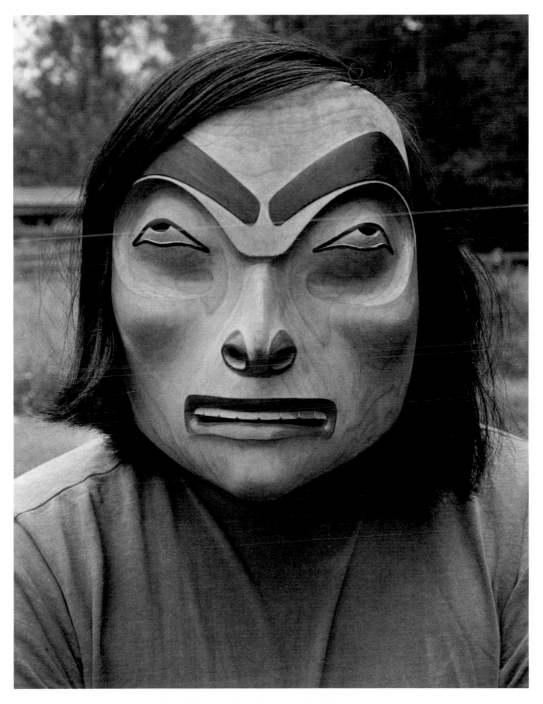

Dead Man *mask, alder, worn by Robert, 1975.*

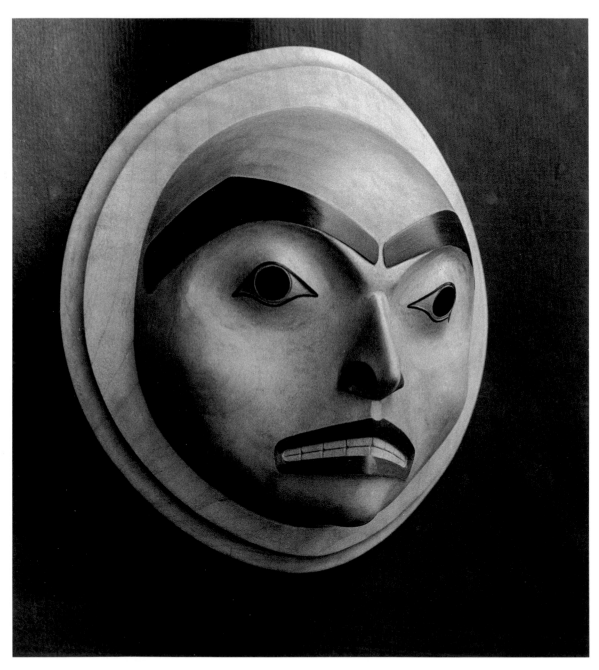

Moon *mask, maple, 1975.*

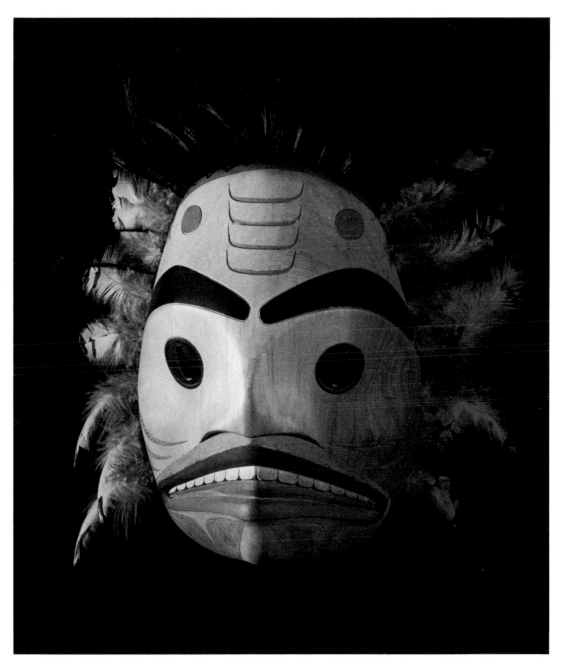

Baby Shark *mask, red cedar, 1981.*

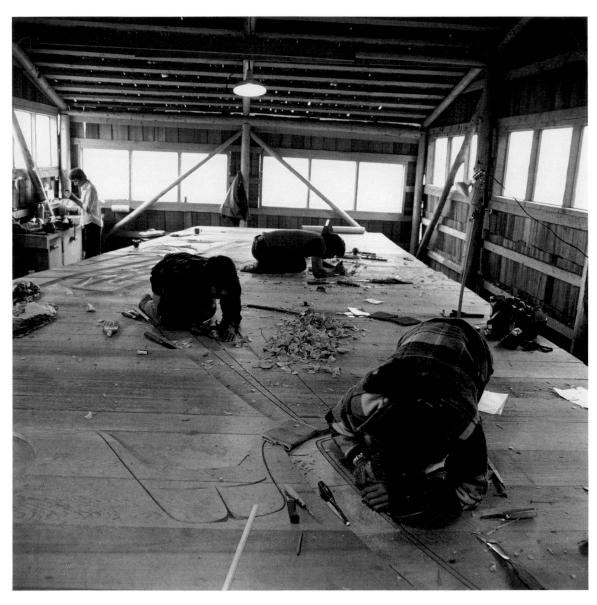

Reg Davidson (left), Robert (right) and Gerry Marks (foreground) carving the housefront for the Charles Edenshaw Memorial Longhouse in 1976.

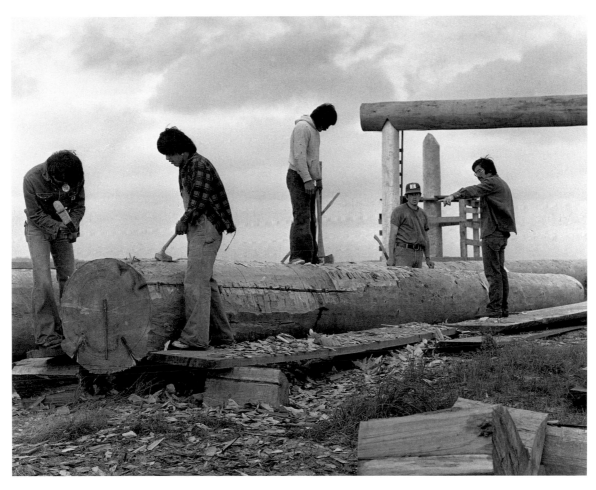

Young men from Massett adzing beams for the Charles Edenshaw Memorial Longhouse in 1978.
Left to right: Alfred Adams, Reg Davidson, Earl Jones, Jim Hart, Robert.

*The Charles Edenshaw Memorial
Longhouse, with its carved and
painted housefront, 1978.*

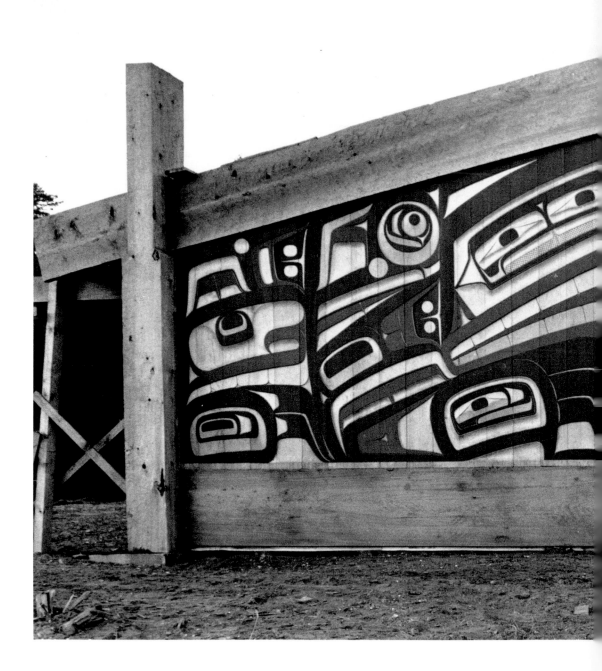

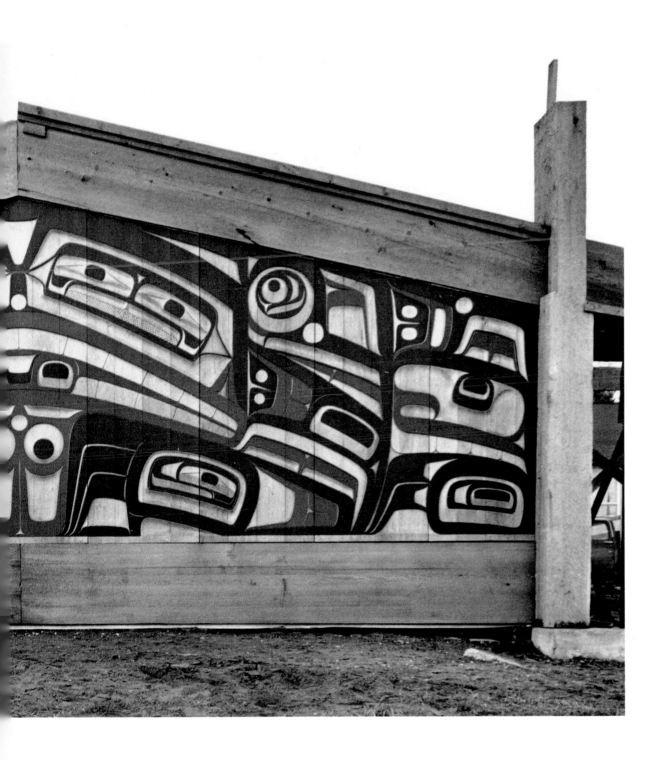

Model poles for the interior house posts of the Charles Edenshaw Memorial Longhouse. The models are yellow cedar: the one for the Raven pole is on the left; the one for the Eagle pole is on the right.

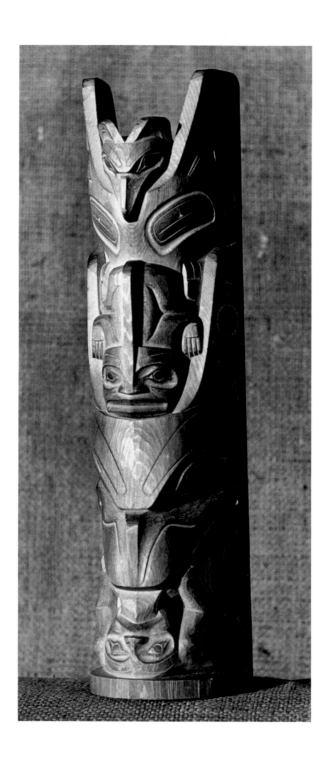

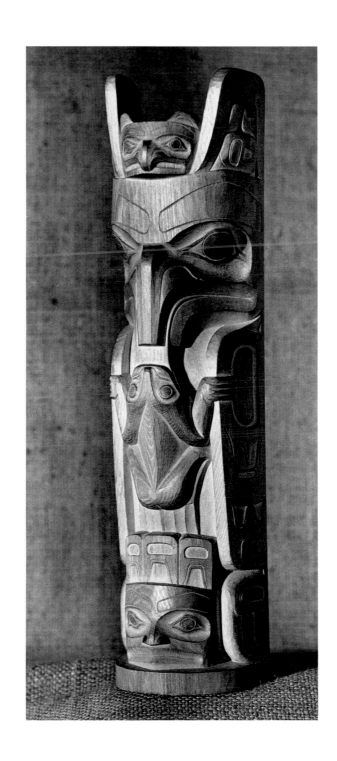

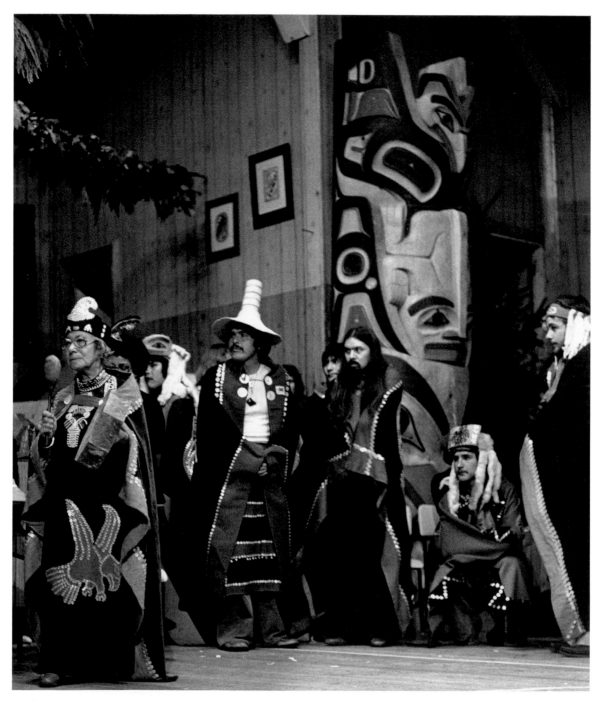

The dedication celebration for the Charles Edenshaw Memorial Longhouse, 1978.
The pole in the background is one of the Raven house posts.
Left to right: *Amanda Edgars, Reg Davidson, Robert, Earl Jones, Gerry Marks, Dickie Bedard, Michael Nicoll.*

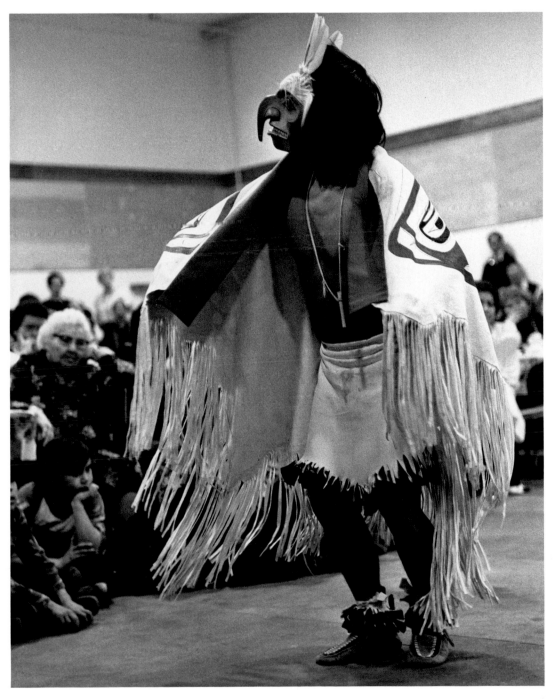

Reg dancing the Eagle Spirit mask (red cedar) that Robert carved in 1980 but did not show until a year later at the ceremony to end the mourning for the Edenshaw Memorial, after it had burned down.

Chapter 3
THE TOTEM POLE

The totem pole is a declaration, a document. The totem displays the images that are our crests. It documents events in a family's life, in the village's life, in the history of the people. It displays the wealth of a clan and a clan's accomplishments, and lays claim to the crests that it displays. Sometimes, poles illustrate legends. Like a play or a movie, a legend is made up of a series of scenes, so a legend can be illustrated by depicting any one of many different scenes. Since, in the past, the totem pole was the only formal visual document, I cannot overstate its importance in our development as a nation.

Traditionally, when a chief took his name, it was his obligation to raise a totem pole in honour of the deceased chief whose position he was filling. And so that totem pole served as a reminder. But there was another meaning behind the totem pole. In order for that totem pole to be, a chief had to have enough wealth to commission carving and raising it, as well as the will to make it all happen. That was one of the tests to demonstrate his capabilities for that position. The chief who commissioned the pole might decide what crests or stories appear on the pole, or the carver might, but the pole displayed only the crests that the chief had the right to use, and sometimes the crests of his wife's clan.

People have to know what property in the way of names, crests, songs, dances and so on they are entitled to. The elders teach us that, but this process has been lost for so many years that our generation no longer carries this knowledge. Some of this cultural knowledge was given to us, but we have been quite removed from a lot of these ideas.

Carving a totem pole is a big commitment. The work takes a lot of energy, and once you get started on one, you have to go nonstop for months.

Red cedar is the wood we traditionally use for carving totem poles because of the height and size to which it grows. Also, it has a natural preservative that helps prevent rot so it weathers very well. It also has a nice straight grain and is easy to carve.

We look for a log that's relatively free of knots and is well rounded and straight. Dry rot in the centre is not a deterrent; it's acceptable for the Haida style of pole since we cut off about one third of the backside, then hollow

it out. Hollowing serves three purposes. One is to take out the heartwood, because the heartwood and the sapwood are the two parts of the log that rot first. Second is to make the pole lighter, so it can be raised more easily. Third is to slow down the checking, or cracking, as the wood dries out. Wood has a lot of moisture in it, and as it dries, it shrinks, and that's what causes checking. The outer surface of the tree dries more quickly because it has a greater area, but cutting out the heartwood helps it to dry more evenly on all surfaces.

After the log is split and the back is hollowed out, we square off the back. If the pole is going to stand on a concrete pad, we install a steel bracket in the back and square off the bottom. But if the pole is going to be stuck into the ground, we leave six to eight feet on the bottom to be buried, depending on the length of the totem pole.

To prepare the surface for carving, we remove the bark and sapwood. The sapwood is the living outer layer of the tree that the sap runs through, and it rots very quickly. It's about an inch thick and is quite a different colour, lighter, from the solid wood beneath.

We calculate the centreline and chalk it on. Then we straighten the log, cut off the flare at the base of the trunk, and round the entire surface as evenly as possible. The tools we use to prepare the log are quite large and industrial: power saws, big adzes, big axes. You have to be in good physical shape at this stage, because of the heavy labour involved. We use all the up-to-date power tools to rough out the creatures on the pole. In the old days, my ancestors didn't balk at using the new iron tools that the white man introduced. Sometimes I balk at the romantics who want us to stay the same as our forefathers.

Once the pole is prepared, the design is transferred on to it. In the early days, I used to stencil the design on the pole. I'd make an actual-size drawing of one side of the pole's design and turn it into a stencil by perforating the lines. I'd stencil the pole on one side, then flip over the drawing and stencil the other side; both sides were the same. The process was long and involved. Eventually, I found it simpler to draw directly onto the log.

After I started training apprentices, I changed methods again. Now, I go

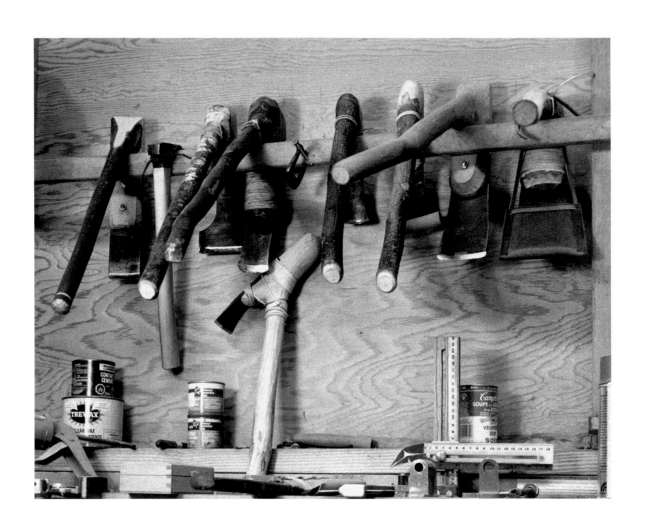

from my drawing of the design to a model of the pole that's in proportion to the log. Going from a drawing to a model doesn't work out exactly, because of changing from the flat to the round. Interesting shapes or complicated shapes or blank areas I hadn't expected appear. And I have to adjust the proportions of the images, since the drawing is two dimensional and the model is three dimensional.

By studying the model, the apprentices can immediately relate to some of the composition planes. With a model, it's easier to show what a plane is or how the design works, rather than trying to explain it. Making a model also helps to solve composition problems.

Measurements are taken off the model pole and transferred to the log. There's a lot of calculation and measuring. Using metric measurements simplifies the process. I also use a calculator and put the ratio, either 6:1 or 12:1, in memory; all I have to do is punch in the number and punch memory to get the exact proportion. We block out the measurements on the actual pole and draw the figures on it. For instance, we draw the eye socket, then the eye pupil, and measure the distance from the pupil to the eye socket. Every space is cross-checked against all the other spaces.

When a design is enlarged from the model to the massive version, the proportions have to be adjusted to the new scale. Blown up to a larger scale, some lines become exaggerated. If a line is out a little bit on a maquette, then when you blow it up five or six times, that line will be out of proportion five or six times. Also, when you enlarge a design, you create bigger spaces; and the bigger the spaces, the more you need to break them up.

Once the design is drawn on the pole, we start to cut into it, start to rough out the figures. Working out the proportions on the pole is easier when the model is still in the rough stage, because you can take more accurate measurements in the square before you start rounding off and sculpting.

The model progresses at the same pace as the pole, but quite often the model is left behind. After we transfer all the proportions and images from the model onto the log, the sculpture takes on its own life.

We constantly check the level and the centreline right through the project. The centreline is vitally important, because all measurements are

Facing page: *"The traditional adze is an incredible tool. It's a universal tool found throughout the world, throughout the ages. The elbow-shaped handle comes from the trunk of a young tree and a limb. You look for a limb growing at a certain angle. There are crucial details, like the angle of the blade to the handle, the proportion of the length of the blade to the handle, the width of the blade. The handle of the adze gives it a little spring that absorbs some of the shock of pounding on the log."*

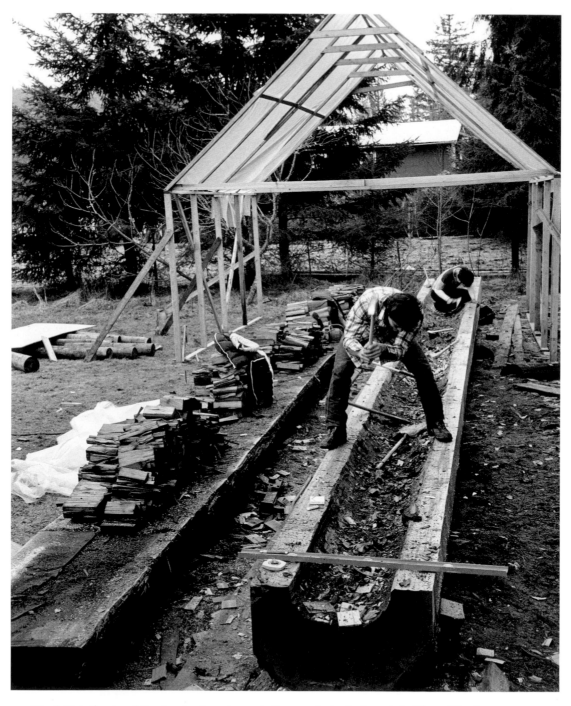

Chuck Heit (front) and Reg (rear) using adzes to hollow out the back of a pole for Three Watchmen, *1984.*
This work consists of a 50-foot central pole flanked by two 30-foot Watchmen.

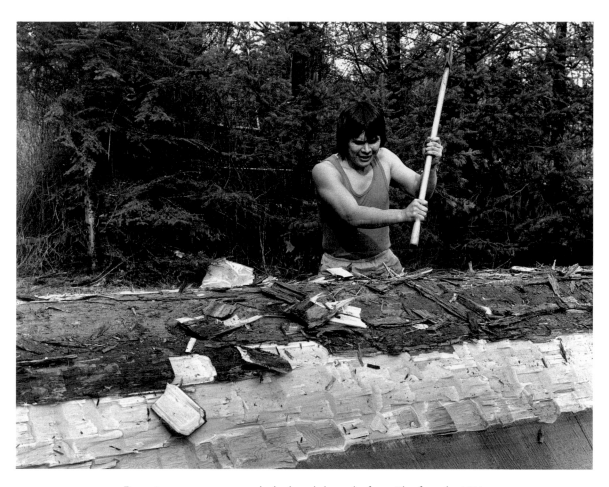

Reg using an axe to remove the bark and shape the front side of a pole, 1984.

made from it. We transfer width and depth measurements at certain points from one side of the pole's centreline to the other.

Using the model as a guide, the apprentices are able to rough out a fair amount of the totem pole. As soon as one area is roughed out, I can start rounding and sculpting. The design on the pole is symmetrical, so I carve one side of a section to a certain stage. The apprentice carves the other side to match up what I've carved. While the apprentice is doing that, I carve one side of another section. I don't work on one figure until it's complete. There's a constant going back and forth. Sometimes we have to space ourselves along the pole so that we're not in each other's way.

Matching up the side I've carved is how the apprentices learn proportion and what to look for. We look at it from different angles to make sure that it looks right: we look at it upside-down or climb up on a ladder and look down. If it looks awkward from one angle, we adjust it. Depending on the experience of the apprentices, I have to make further adjustments. They may go too deep or not deep enough, or they haven't fully grasped what the shape should be.

I always start sculpting with a figure's forehead, the space between the bridge of the nose and the top of the head. After bringing that forehead down close to the depth it's supposed to be, I form the forehead, carving towards the back of the pole. When the forehead's established, I form the eyes, based on the plane of the forehead, and then do the mouth.

I use the forehead to establish the proportion of the head. From that comes the proportion of the body. Sculpting is challenging because you're dealing with three dimensions, with space, shadow, depth, profile. It's not like graphics, where you adjust one line and adjust the other one to it. In sculpting, you're constantly moving things. If you move an eye, then you've got to move the nostril and the mouth; then you find you've got to move the forehead. You have to keep adjusting until you're happy with the proportion and composition.

The planes are very important: they're all interconnected, they're all part of the unit. Each indentation is in proportion to the others. Everything is in proportion to everything else.

Once we start to round and sculpt, we switch to more refined tools like smaller adzes, chisels, the pounding chisels. We use these tools all the way through to completion. A few tools do get smaller and smaller to accommodate the small spaces that need to be carved, like the corners of eyes. Sometimes I even get out my jewellery tools. I'm always drawing on my experience from one medium to another, whether it's jewellery or painting or sculpting. The last three prints I did played with creating different spaces, new spaces; that came from carving totem poles, where you find new spaces within that piece of wood.

When the sculpting's done, we move on to the undercutting. For example, a tongue on the old poles would be lying flat. But when the tongue is undercut, there's air underneath it. Undercutting is a technique that was used by a few old masters who didn't worry about having to pay the bills on Friday. It takes extra effort, extra care, extra time – about double or triple the time. Undercuts appear in some of the exquisitely carved miniature masterpieces. There was a lot of very deep carving, and on some carvings the undercut of the eye socket was very deep. The scoring of the lines to indicate the eyebrows, the eyes and teeth were all proportionally carved for depth. The undercut is also a surprise for the viewer. The person who discovers the undercut wants to look further, and I like to bring the viewer into the image to discover more things.

For doing undercuts, I have an entirely different set of tools that are odd shapes. On an undercut, you're always working either with the grain or against the grain, so you have to invent special tools. The reason for undercutting is to create magic. For example, to create the illusion that, if there's an arm resting on a leg, the continuation is there. The old totem poles didn't have much undercutting; they had tricks to avoid doing it. But in the latter part of that classical era, the totem poles became more structural and undercutting was used to show a lot more of hands, arms and legs. Those poles were three dimensional in comparison with the old-style totem poles, which were two dimensional on a round cylinder.

When I started, I made my own tools. Back then there weren't any toolmakers – now that there are, I custom order my tools. But I still like to

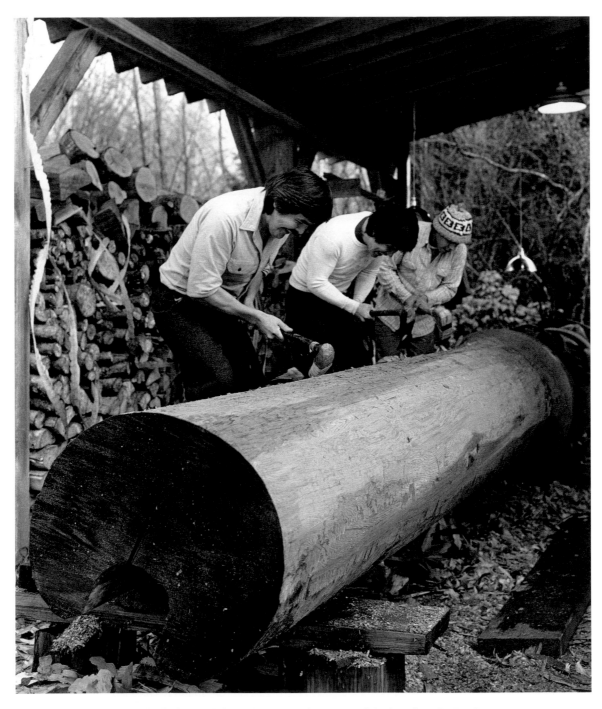

Robert, Reg and Chuck Heit (left to right) using adzes to round the hat of a side Watchman, 1984.

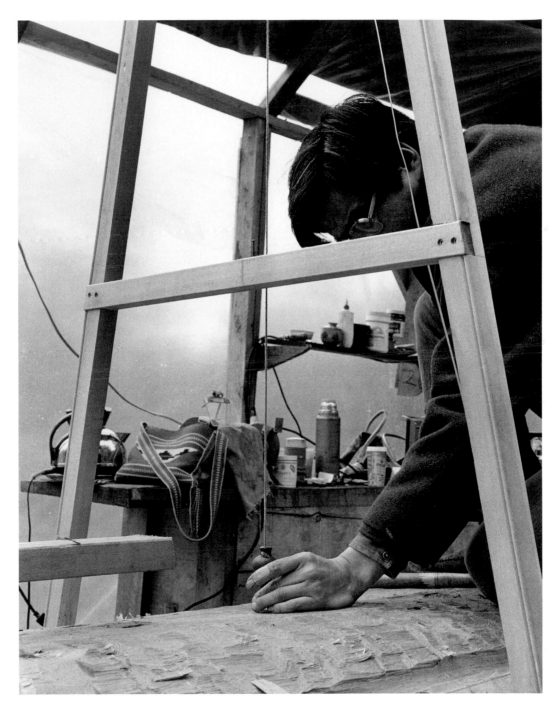

Robert using an A-frame device to establish the centre line on a pole, 1984.

shape the blades myself to the curves I want. There are times I have to make a special tool – I need it right then for an awkward space. When you're sculpting, you're visualizing shapes, and you also have to visualize the tools that'll work in that space. I'm always experimenting with using different tools in different spaces. I have three or four favourite shapes that I use a lot, but as I push an idea further and further, then the tools I need become more complicated. I really marvel at some of those old masters who didn't have the tools I have, yet were able to create that magic.

I can't even count how many tools I have. One apprentice jokingly said to me, "You know, I came in with tools that I could pack in one hand, and when I left working with you I had to use a wheelbarrow to carry all my tools out."

A lot of people have worked with me or apprenticed with me, but not many of them stay. They have to really want to learn to carve, to really really want it. The key to teaching apprentices is communication. It's not only work, there's a lot of theory involved, a lot of discussion. I tell them I learned to imitate the style of each of my teachers very well. I went from my father's style to my grandfather's style to Bill Reid's style, and then I started to imitate and copy Charles Edenshaw. When I started to gain more confidence in myself, I had to spend a lot of time unlearning all those styles in order to develop my own.

My brother Reg was a unique apprentice. He was my spirit helper. He gave me moral support, physical support, and at the same time he was learning the artform. After helping me carve that totem pole at Massett in 1969, he was involved in every major project of mine until he was ready to move on. I don't take credit for Reg's success; what he did was because of his own enthusiasm and the effort he puts into developing his own style. He really shines in carving totem poles.

There were other carvers who worked with me, but only for a very short time. I know a lot of the effort came from themselves, so I can't say I had that much influence on them. They've gone on to become very successful.

After the sculpting and rounding are done, it's time to put the finish on the pole. On the first three totem poles, I used a textured finish. That is a

traditional technique, but as I started to understand sharpening and using chisels more and more, I preferred a smooth finish without texturing.

The finishing of a totem pole is all done with tools, curved knives or chisels. I've been accused of sanding my totem poles, and I really enjoy that, it's a compliment. The tools are sharp and any little flaw in the edge shows up in the wood, so we sharpen the blades until there are no nicks in the edge. If I added up all the time I spend sharpening in a day, it would be about two hours. We all have our own way of sharpening, and all our tools have our personality.

I paint all of my poles. The only one that isn't painted is the first one I carved. There's always a dilemma about whether to paint or not. I'm sure that if you did a survey, fifty per cent would be for it and a fifty per cent against it. It's really up to the artist. Sometimes I wonder why I put all that work into it if nobody's even going to notice, so I paint my poles in order to highlight and exaggerate features and to define shapes. Also, I love colour.

I use an exterior latex paint. You have to repaint a pole periodically, like any house or any outdoor object. The colours I use are traditional: red, black and sometimes a blue-green. The red I use is a nice brilliant one, and I still get excited when I'm using that colour. I don't have any real desire to try new colours on the poles, though I have in my graphic painting. With totem poles, I explore shapes more than I explore colour.

There are rules for painting a pole. Traditionally, lips and nostrils are red, eyes black, eyebrows red, ears black; when I paint the body, more often than not, it's red. The wings are red or black, depending on the artist. The pectoral fins and tails of killer whales are black or red, again depending on the artist. That's the basic colour scheme of a totem pole, but the real challenge is the shapes, not the colour.

The apprentices paint the poles. Painting serves two functions for the apprentice. They learn how to paint and what to paint. They also absorb some of the shapes by osmosis – they don't realize they are actually absorbing some of those shapes, some of that magic.

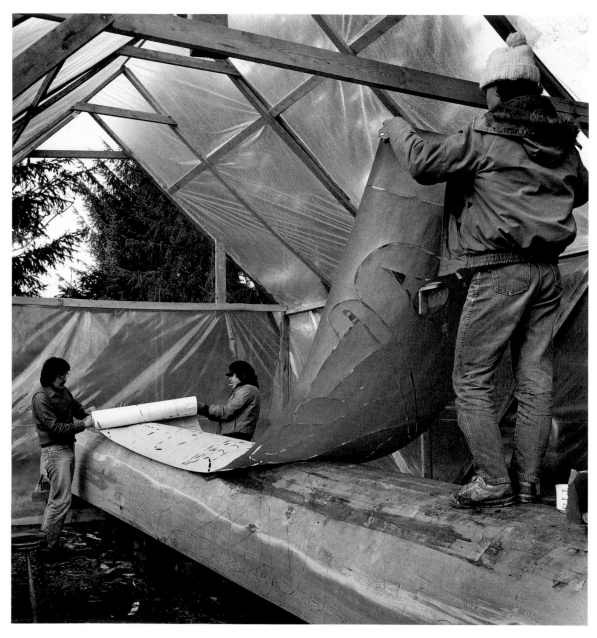

Having used a stencil to transfer the design onto one side of the log, Robert, Reg and Chuck (left to right) are flipping the stencil to do the other side, 1984.

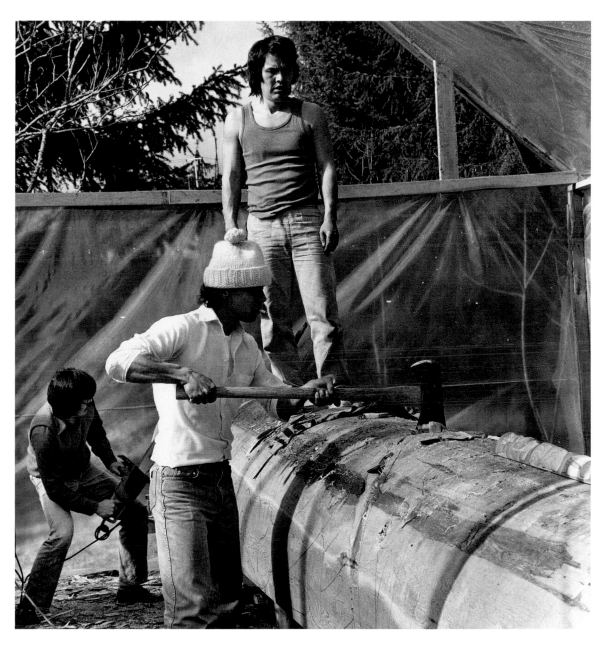

Making the first cuts into the log, 1984. Robert is using an electric saw and Chuck is using an axe, while Reg stands on the pole.

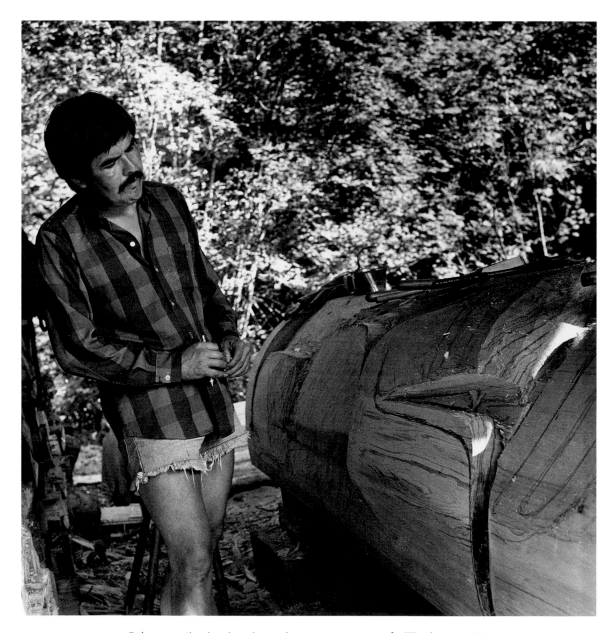

Robert, pencil in hand, making adjustments to an arm of a Watchman, 1984.

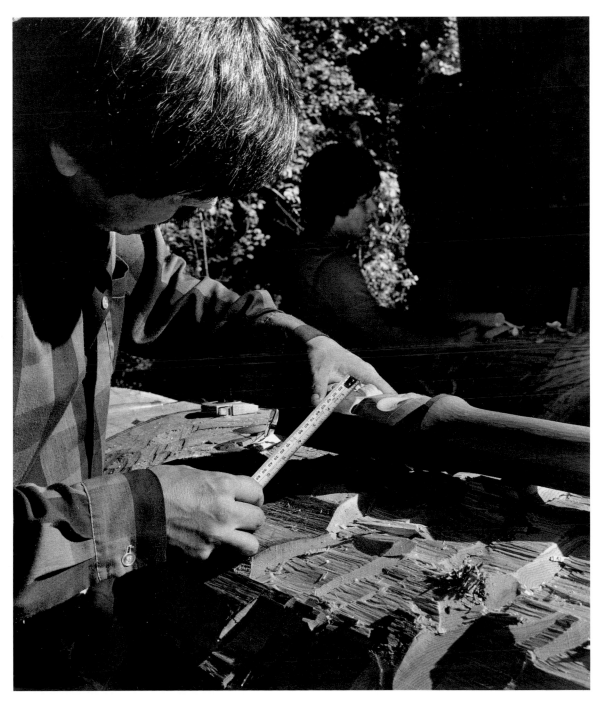

Robert taking measurements from a maquette to transfer to the actual pole; Reg is in the background, 1984.

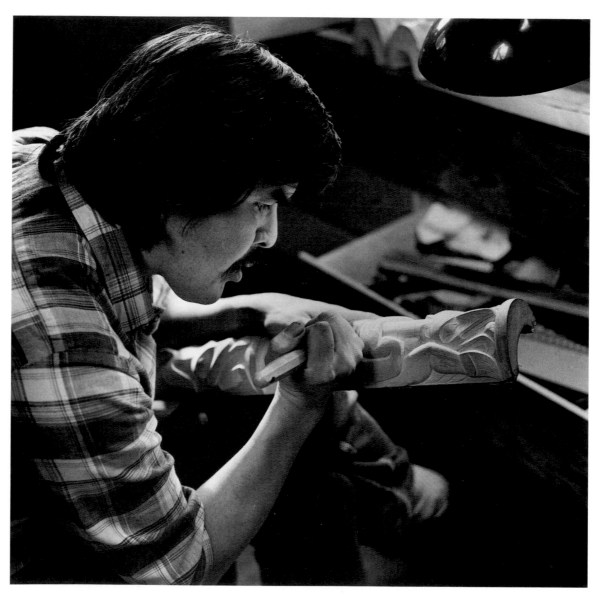

Robert using a small chisel to put the finishing touches on the maquette (yellow cedar) for the central Three Watchmen *pole, 1984.*

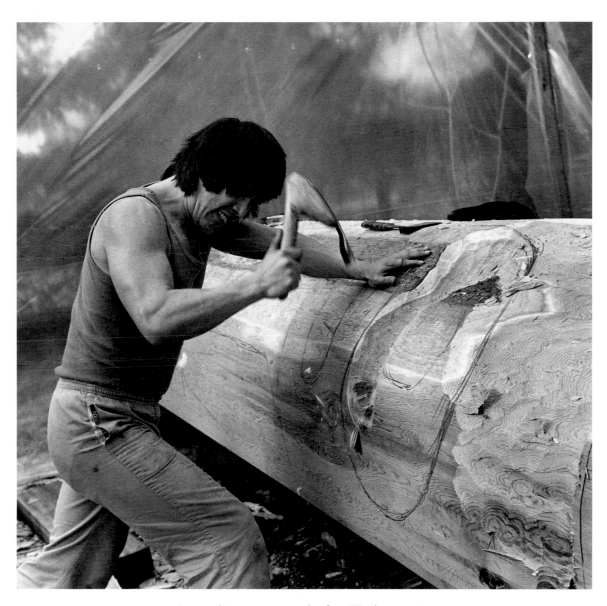

Reg roughing out an eye socket for a Watchman, 1984.

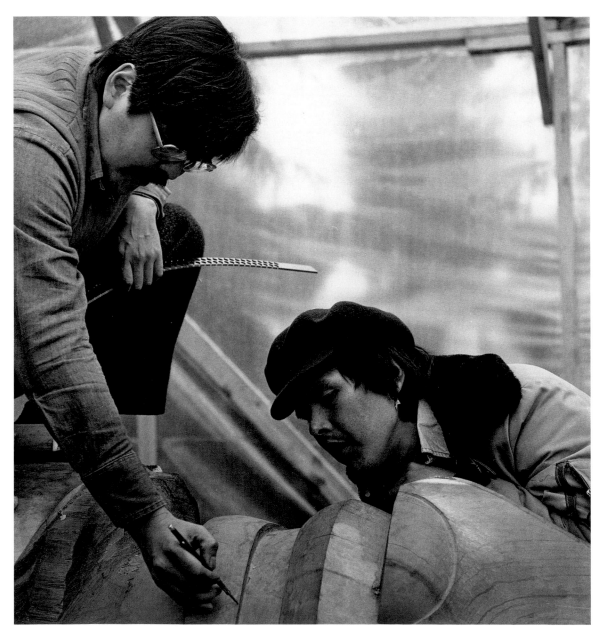

Robert, a flexible ruler in one hand and a pencil in the other, showing Reg how to adjust the lip of a Watchman, 1984.

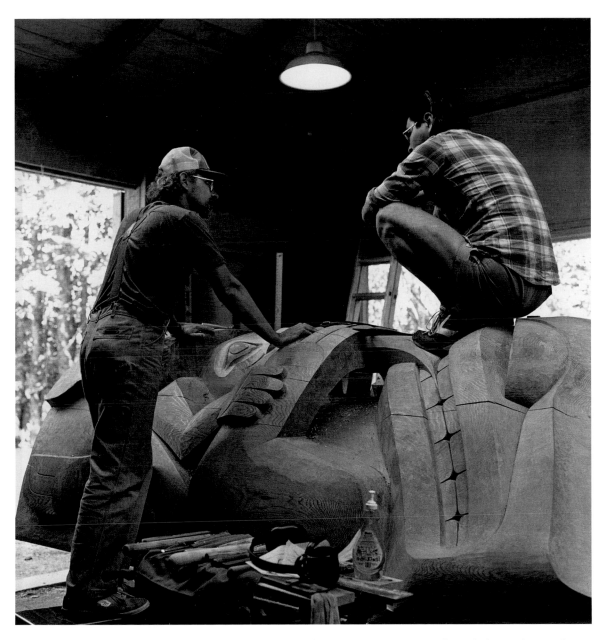

Glen Rabena (left) and Robert discussing one of the poles for Three Variations on Killer Whale Myths, *1986.*

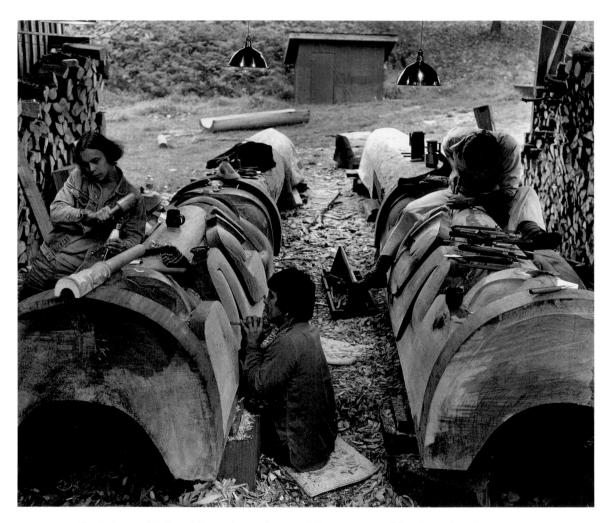

Chuck, Reg and Robert (left to right) working on different sections of the Three Watchmen, *1984.*

Friday payday, and Reg leaves work, holding his cheque; Robert is in the background.

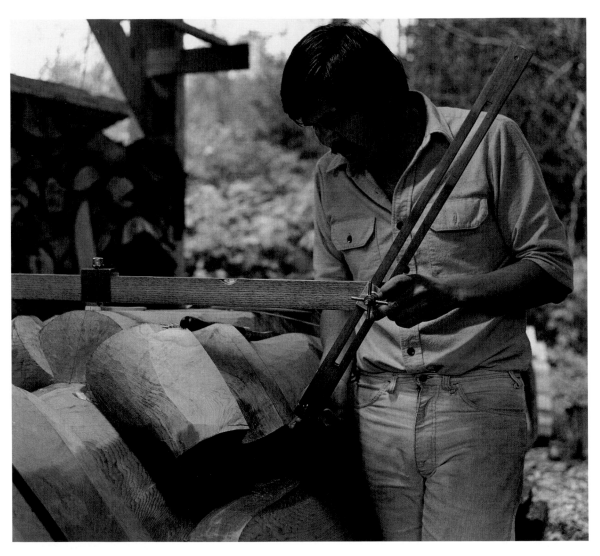

"We transfer width and depth measurements from one side of the pole's centreline to the other with a tool invented by Bill Reid. It's a level with an adjustable arm. To transfer a certain point, you place the level across the pole and measure the depth with the adjustable arm. Then you flip the arm over to the other side. I call the tool 'the rabbit' and I call the point I am transferring to the other side 'the turtle': so it's rabbit racing turtle."

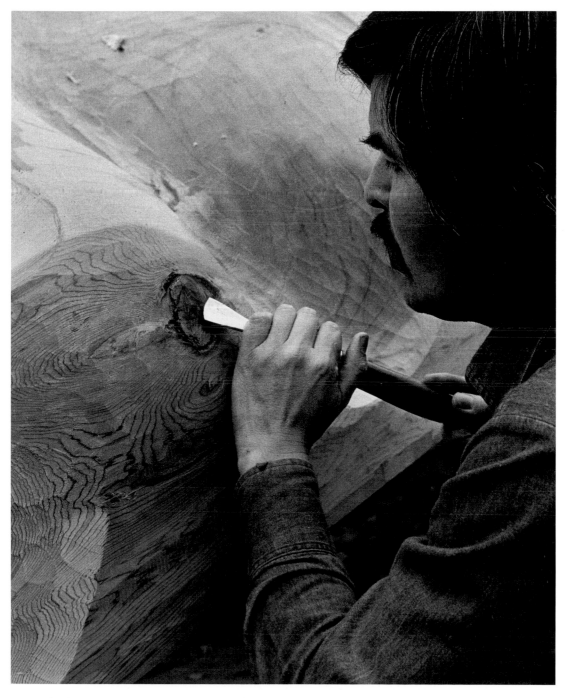

"With a knot, the grain may be going in three different directions all at once. I enjoy the challenge of making a part work with that knot there. We have all kinds of power tools that I'm not shy about using, but only in the rough stage. After that I prefer to use hand tools, which are quieter and more methodical."

Reg with potential adze handles gathered from alder trees outside Robert's carving shed, 1984.

Some adze handles and a completed adze.

MAJOR WORKS FROM THE EARLY 1980S

There was a big gap between the time I carved the pole in 1969 and the two in 1970, until I did another one in 1984. There was no particular reason; it probably had something to do with my own progression as an artist.

Facing page: *The yellow cedar model for the 50-foot Three Watchmen pole, 1983.*

In becoming an artist, I've gone through four levels. The first was being an apprentice, working with my father, working with my grandfather, working with Bill Reid. I also did a lot of studying and talked with other artists. That period was a learning time, learning from knowledge in people's heads and knowledge stored in museums.

In the second level, as a journeyman, I began to interpret the knowledge I had gained. I came to understand this stage of the process through my favourite song of that time called "Me and Bobbie McGee." I loved the song so much that I collected a lot of versions of it by different singers. Each singer had his or her own variation or interpretation of that song. And I was doing my own variation or interpretation of existing images, of masterpieces in museums.

The third level, master, was a time of experimenting beyond the established. I was exploring, mapping new worlds. I played with new ideas, trying to express and complete them; sometimes the images didn't work. The ones that do work become part of the culture, part of the artform. The ones that don't work become part of the experience.

The fourth and final level is being an artist. With the confidence and experience gained over the years, you can start to expand the boundaries. When you look at the creations of my ancestors, you can notice developments, you can recognize different artists, you can see how different artists introduced innovations.

When I'm commissioned to produce a work, I talk with the client to see what images come to mind. When I'm inspired, those images come spontaneously, and I capture them in pencil drawings. I may see several images right away, or it may take days, even weeks. Those images can only come in moments of quiet.

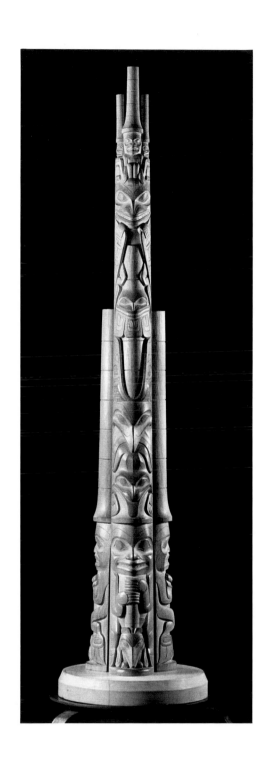

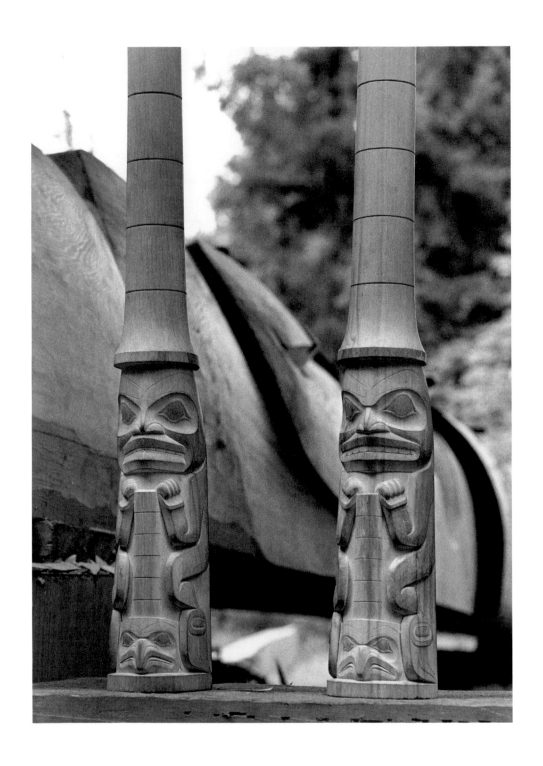

THE *THREE WATCHMEN* POLE, 1984

In 1984, the Maclean-Hunter people approached me to carve a pole for their building at a development called College Park in Toronto. When they described the site and space to me, I became excited by the opportunity to take a totem pole beyond what it is intended to be. A totem pole's function is to be a marker in front of a house, to display the history of that family or declare certain rights or stories. In this case the pole was to be indoors, in the atrium of an office building, and could be viewed from many levels on all sides.

At first, I visualized three totem poles, but then I thought of the Three Watchmen. The job of the Three Watchmen is to ensure the safety of the village, to give warning of attacks. Nobody ever sees them because they're always way up at the top of a pole. I decided to take the Three Watchmen and put them at the bottom instead, so people could see them.

I placed the Three Watchmen in a form of a triangle, two of them on two short poles and one at the base of a tall pole. The Watchmen wear high hats with rings around them. The rings on the hat symbolize high rank; each ring represents a potlatch the wearer has hosted. You can see the hats of the Watchmen on the sides. The middle Watchman usually has the tallest hat, and I designed it so that his hat actually becomes the totem pole. If you look carefully at the centre pole, you can see that the rings for his hat are there.

In between the feet of each Watchman is a bird, and each bird symbolizes a different tense: past, present and future. The past is symbolized by Eagle, which is my crest, my cultural past.

The present is Raven. Raven didn't create the world, but he knew where all the parts were throughout the universe. He used his cunning and conniving to put all the parts together to form the world as we know it today.

The bird for the future is Tliia, a bird that whistles, but nobody ever sees it; the only person who has licence to give it form is the artist.

Each bird is wearing a hat, and the middle Watchman is hanging onto the hat of the Raven, to indicate the importance of the present moment. We can't live in the past or the future.

Facing page: *Close-up of the yellow cedar models for the two 30-foot side Watchmen for* Three Watchmen, *1983.*

⋮

75

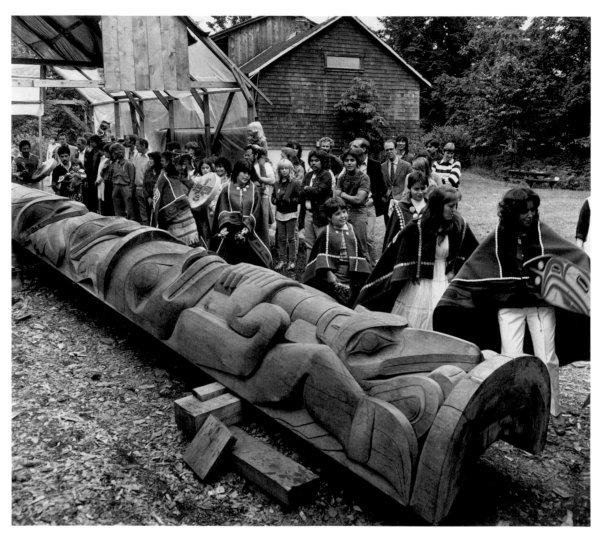

Celebrating the completion of Three Watchmen *at Robert's studio in Whonnock, 1984.*

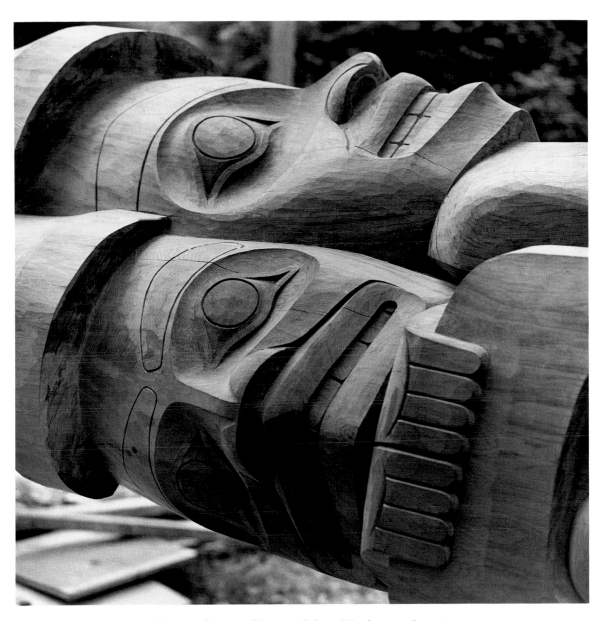

Close-up of the top of the central Three Watchmen *pole, 1984.*

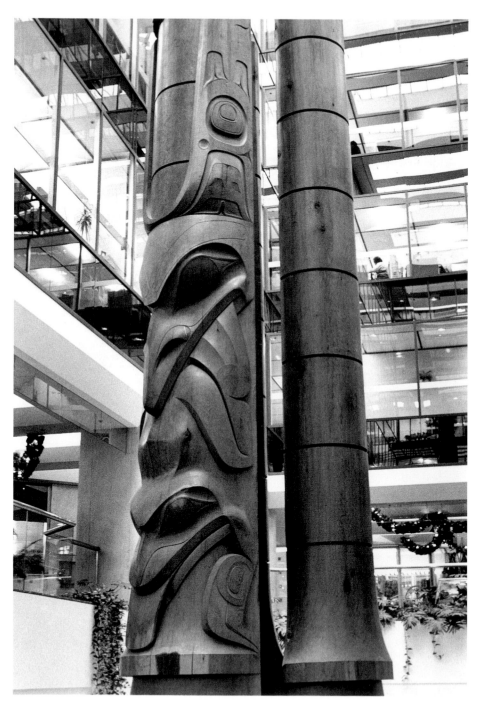

Section of the central Three Watchmen *pole, showing the brim of the bottom Watchman's hat (bottom); the Frog is above, in the mouth of the Raven; above the Raven is the continuation of the hat, with rings carved into it. To the right is the ringed hat of one of the side Watchmen.*

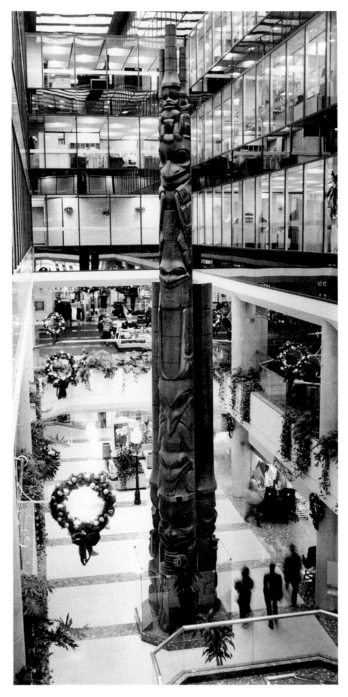

The 50-foot Three Watchmen *pole installed in the atrium of the Maclean-Hunter building in the College Park development in Toronto, 1984.*

⋮

Above the middle Watchman is a Raven with a Frog in its beak; that Raven is echoing the bottom Raven, and the Frog is a spirit helper. And above that is another Raven in semihuman form, with a Frog in the tail joint; Raven has the ability to transform into different objects or people. Here, he's transforming into a human; he has kind of a smirky smile and he's displaying the Three Watchmen on top. His grin is saying, "I still have the power to hold all three tenses at one moment."

The pole took eight months to carve with the help of two apprentices, Reg Davidson and Chuck Heit. The centre pole is 50 feet tall, and the two side ones are each 30 feet. We couldn't raise the poles the usual way. In fact we called it a "totem pole dropping," because they had to be dropped in through the skylight. That was the only way to get the poles into the atrium, which was ten storeys high. They had to use a fifteen-storey crane, and the tallest totem pole looked like a toothpick when the crane was hoisting it up outside the building.

THE TALKING STICK, 1984

When I have private clients from Toronto or New York or Montreal or Japan, I don't treat them any differently from the way I would treat a chief from my own village. I try to make each pole meaningful to the person who commissions it.

In 1984 the Catholic Church in Vancouver commissioned me to carve a talking stick for Pope John Paul II, to commemorate his visit to Vancouver. The talking stick is a symbol of authority in our culture that gives the person holding it the right to speak. A talking stick often looks like a model of a totem pole.

The Pope is head of the Catholic Church, so the symbols that I chose to represent him were Thunderbird and Killer Whale. Thunderbird because when the Pope speaks, he speaks with thunder. Everybody stops to listen. Killer Whale because in our language it is called Sgan, which means "supernatural," and also because Sgan is chief of the underworld. A hole in the Killer Whale's dorsal fin indicates that it has supernatural

Facing page: The 62-inch talking stick made for Pope John Paul II, shown here supported on a circular base. Near the middle is the head of the Killer Whale, with its dorsal fin going right to the top of the stick.

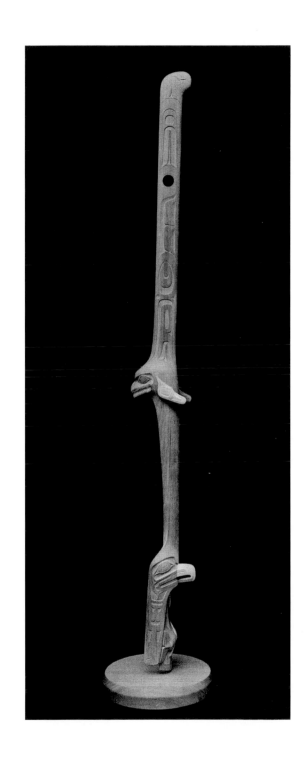

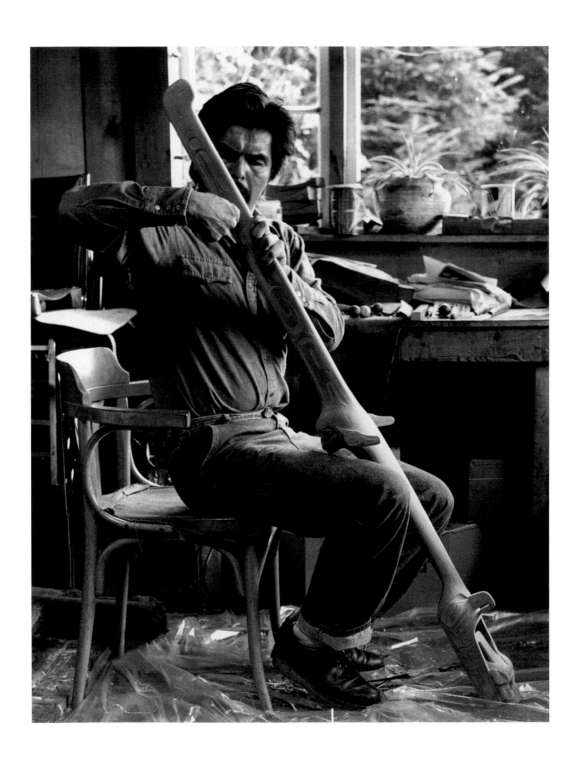

qualities, so I put the hole in the dorsal fin to symbolize that the Pope is a supernatural figurehead.

THREE VARIATIONS ON KILLER WHALE MYTHS, 1986

I was recommended to the people at Pepsi Cola by three very prominent people in Northwest Coast art circles: Bill Holm, George MacDonald and Marjorie Halpin. The company flew me out to the east coast to see their sculpture garden. I was overwhelmed by the presentation and the care they'd taken with each artist's sculpture. I was just awestruck that my work would be among that of the great artists they have there, like Henry Moore, Noguchi, Rodin. Pepsi Cola had very high standards and they demanded a lot. They decided on three poles in order to make a strong statement. One pole wasn't enough and two were too symmetrical; there had to be an odd number. They settled on logs with a diameter of four feet, but a couple of weeks later the director phoned me and said, "Let's make them as big as we can make them." I was challenged to go beyond the average size in diameter. Going from a diameter of four feet to five feet was exciting. Those are the biggest poles I've done, in girth.

I presented Pepsico with drawings, and they accepted them, but the totem poles took different shapes from the drawings. Fortunately they gave me a lot of leeway.

The three poles weren't meant to be a set. They work as a set, but they also have the strength to stand independent from each other. You can see a very definite progression in terms of confidence and experience from the first pole to the second pole to the third pole. The first totem pole is very traditional, in the old Haida style of a two-dimensional wraparound. The second one is a little more free flowing and experimental, a little more daring. The third one is bolder and a lot more abstract.

The whole project is called *Three Variations on Killer Whale Myths.* The Wolves and Killer Whales on the first pole refer to a story about a mother-in-law claiming power. She has a lazy son-in-law, so she makes fun of him and claims that she has power. The son-in-law traps the Sea Wolf, puts on its skin, then captures the Killer Whale and brings it to the village. The

Facing page: *Robert at work carving the talking stick in his father Claude's studio in Massett, 1984.*

Facing page: *Detail of the Thunderbird at the bottom of the talking stick made for Pope John Paul II. The tail flukes of the Killer Whale that forms the top half of the stick are also the wings of the Thunderbird, and the Thunderbird's head is in the joint of that Killer Whale's tail. The Thunderbird is also clutching the head of a second Killer Whale.*

mother-in-law claims to be a *sgaaga,* so she predicts how many whales she will land on the beach the next day. Eventually it's made known that it was the son-in-law who captured the whales, and the mother-in-law dies of shame. The whole story is more involved than this.

The second pole is about Killer Whale and Thunderbird. Killer Whale is the traditional food of Thunderbird. The word for Killer Whale in Haida is Sgan, which means "supernatural" and also "the chief of the underworld." In myth times, Killer Whale was chief of the underworld. They say that when you go underwater to visit the territory of the Killer Whales, it's no different from being on land, except that because you're in their world, you see them as humans.

The third pole, the centre one, pushes the form more. It depicts the story of Nanasimget, in which a man pursues Killer Whale who has kidnapped his wife.

The poles took long hours and many months to carve, thirteen months with two apprentices, Reg Davidson and Glen Rabena. The heights were 32 feet, 31 feet and 35 feet. The diameters were five feet, four foot ten and four foot four.

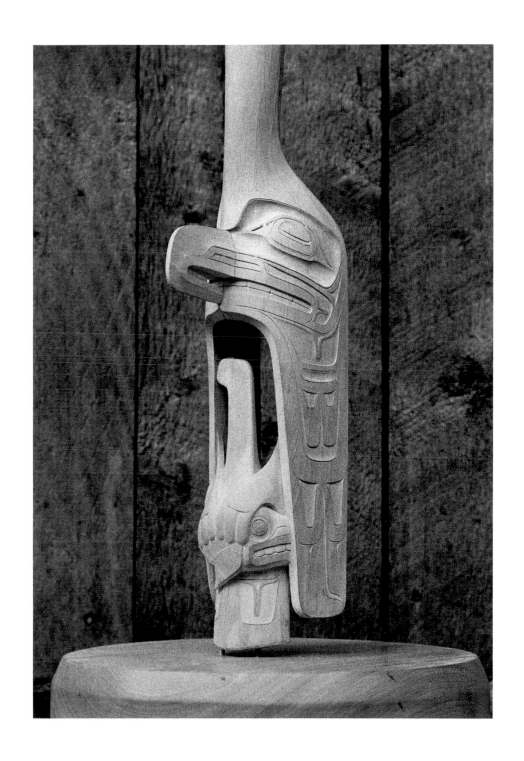

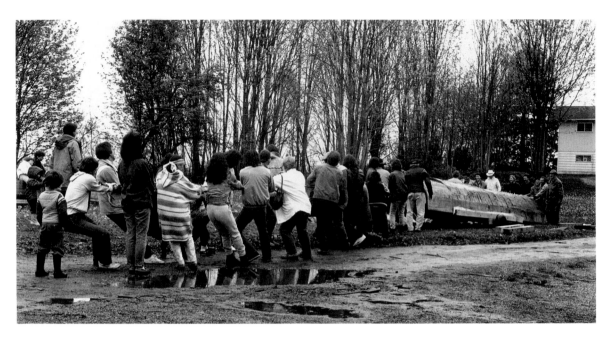

Robert's friends pull a pole for Three Variations on Killer Whale Myths *into the carving shed, 1985.*

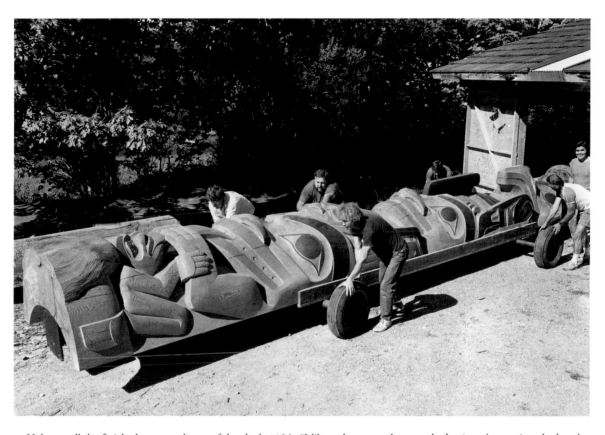

Helpers roll the finished centre pole out of the shed, 1986. "I like to have people carry the log into the carving shed and pull out the finished pole. I like to create events to bring people together. It's a communal thing. I also like to involve my friend Earl Carter and his partner Kevin Helenius. They have a great knack for moving big logs. We used to put the log on rollers, and that was a real chore because you're pulling against a lot of weight; but with the wheel axle that Kevin designed, it's more like moving a car."

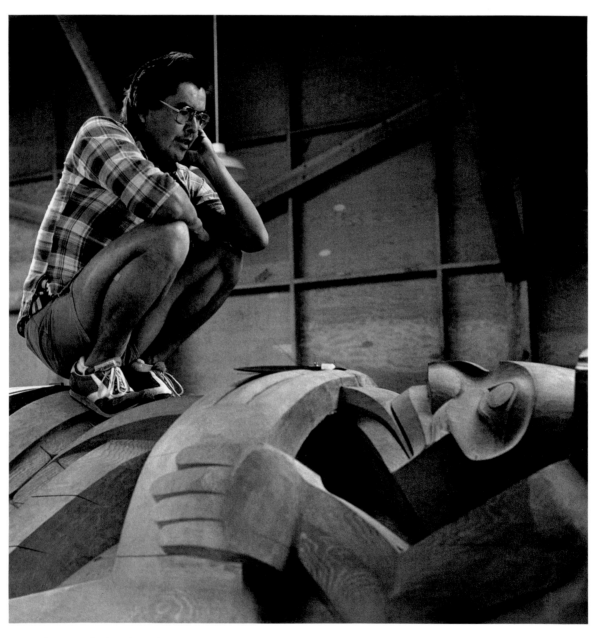

Robert, crouched on the undercut tongue that the kidnapped wife shares with the Killer Whale on the centre pole of
Three Variations on Killer Whale Myths, *1986.*

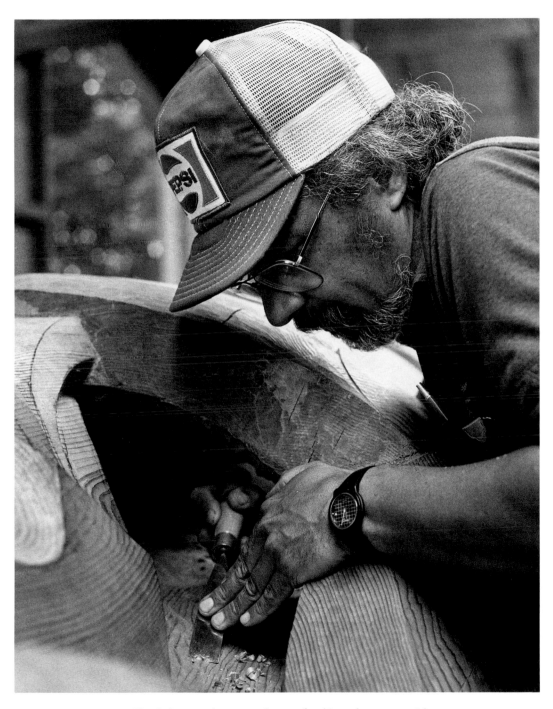

Glen Rabena working on undercuts of a chin and an arm, 1986.

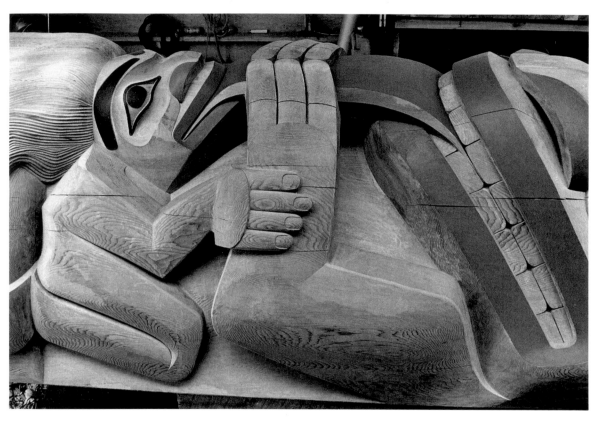

Details of sections from the centre pole. Close-up of the hands of the kidnapped wife and the Killer Whale.

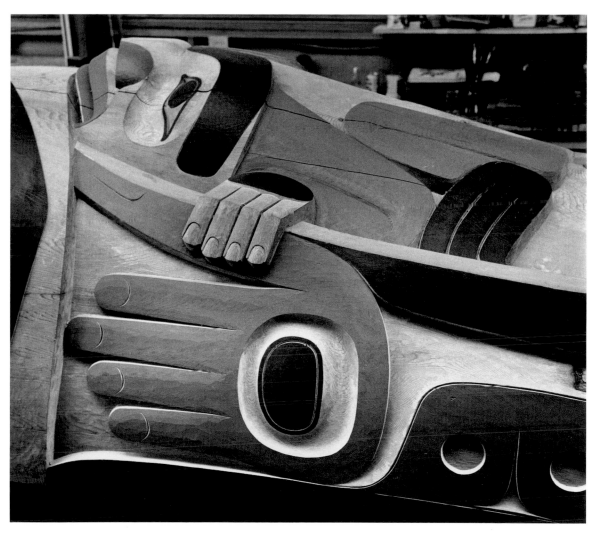

The husband's large hand comes through the Whale's pectoral fin, and the Frog's hand clasps the fin and the husband's thumb; the Frog's face on the left is the blowhole of the Killer Whale. A blowhole can be represented either by a small circle or a face on the Whale's forehead.

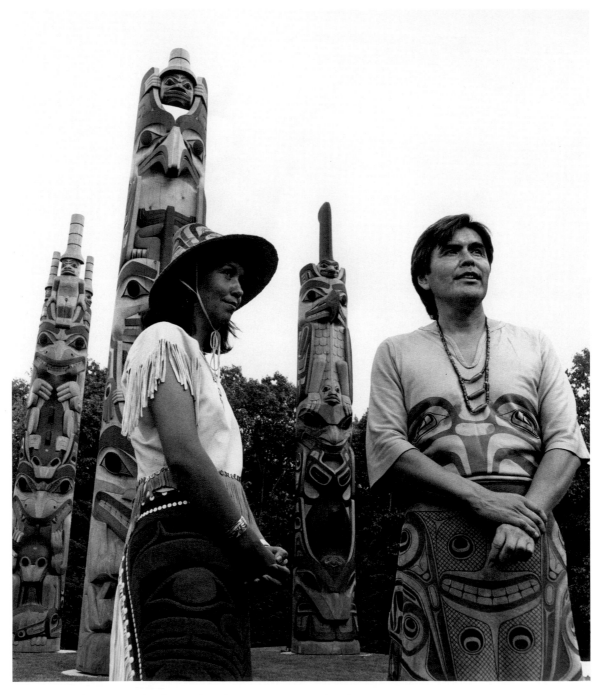

Dorothy Grant and Robert at the pole-raising ceremonies for Three Variations on Killer Whale Myths
*at the Pepsico sculpture park in Purchase, New York, 1986. They are looking up at an eagle
that flew over the site just as the last pole was raised.*

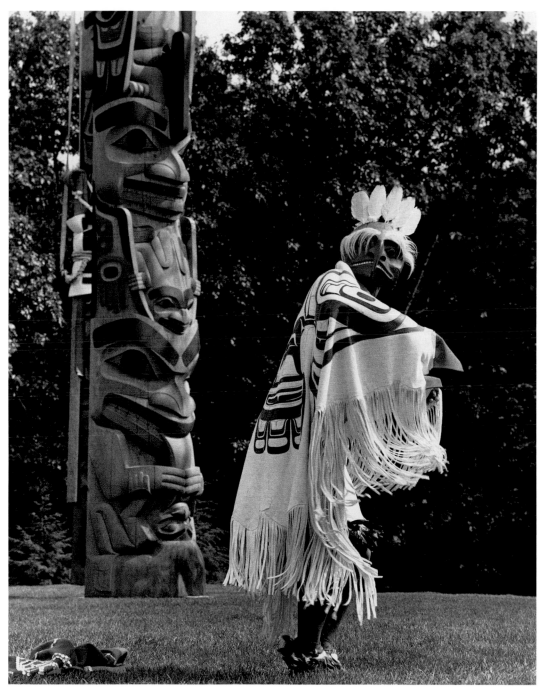

Reg dancing the Eagle Spirit *mask, which Robert carved in 1980, at the pole-raising ceremonies for* Three Variations on Killer Whale Myths, *1986.*

The three yellow cedar models for Three Variations on Killer Whale Myths. *Facing page: The full-size poles.*

"The first pole (left) depicts two Wolves, one above the other, each with a Killer Whale in its mouth. The body of the bottom Killer Whale wraps sideways around the base of the pole. At the top are Three Watchmen, whose legs come through the ears of the top Wolf.

"The second pole (right) shows Killer Whale in two states, at the bottom in animal form as it is in our world and above that in semi-human form as it is in the underworld. They share the same tail, and each has a face for the blowhole. Above them is Thunderbird, its tail stretching down the pole and coming out through the mouth of the bottom Killer Whale. The dorsal fin of the second Killer Whale comes up through the breast of Thunderbird and continues above it to form the top of the pole. Between Thunderbird's ears is a third small Killer Whale, which also shares that elongated dorsal fin.

"The third pole (centre) has Killer Whale on the bottom in human form, sharing its tongue with the kidnapped wife, whose beautiful flowing hair is at the base. That idea came to me when I was walking across the bridge over the river by my studio; as I looked down into the water at low tide with the water going out, the eelgrass was flowing beautifully. Subconsciously, the wife's hair became like that eelgrass. Above that is the husband. The body of the Killer Whale goes right through the whole totem pole, and its dorsal fin comes out through the husband's forehead. On his chest is a Frog, whose face is the blowhole of the Killer Whale. Next is Eagle, whose ears are also the Killer Whale's tail flukes; between those ears is one Watchman. I put the Eagle there to acknowledge the Americans who commissioned the pole."

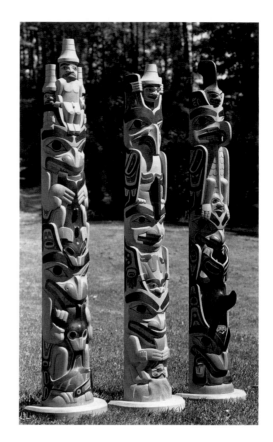

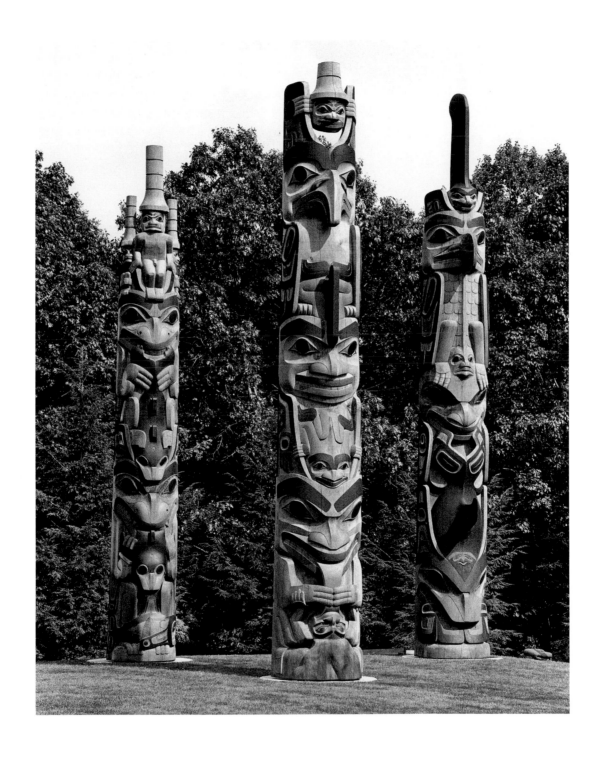

Chapter 5

THE MASK

The Haida word for mask is *niijanguu,* which means "to copy." So when I make a mask, it's actually copying an image or an idea from the spirit world. I believe that we're connected to the supernatural or spirit world through our minds. When I create a new mask or dance or image, I'm a medium to transmit those images from the spirit world. Masks give form to thoughts. Masks are images that shine through us from the spirit world.

The Haida word for mask also means "to imitate." So when you make a Killer Whale mask, then you're imitating the Killer Whale. If you do a Grizzly Bear mask, you're imitating the Grizzly Bear. It's almost like going into a trance: you become that Eagle, you become that Grizzly Bear, you become that Raven.

Masks also help to bring you into a particular state of mind. They are objects of the images that we carry around in our minds, and the masked dances are re-enactments of our dreams and memories.

Alder and red cedar are the two woods that I use for making masks. Alder is a little heavier and denser than cedar, and you can carve very fine detail in it. Red cedar is less dense and it's not a very forgiving wood – I find it a challenge and like to push it beyond its limitations.

The format of the mask, whether it's long or flat, determines whether I use the edge grain or the flat grain. The edge grain is the easiest to carve. You take a round of wood from a tree and cut that in half, like splitting firewood; then you get the edge grain. But if you cut a slice off the round, like a slice of meat, then you get the side grain. Side grain is more difficult to carve, because of the soft wood in between each ring. I look for a tight grain where the rings are really close together. For masks, the wood has to be free of knots. And the grain has to be straight grain; when you split it, it has to split straight.

The tools I use for carving a mask are the same as those I use for carving a totem pole, though some of them are a little more refined. It can take four to six weeks to make a mask with an apprentice, but it's not a full six weeks, since I'm doing one or two other pieces at the same time.

On the masks, the copper inlays and operculum (a kind of shell) that I use for teeth are from the jewellery experience. Edenshaw's argillite

Facing page: *Robert carving a* Shark *mask, red cedar, 1988.*

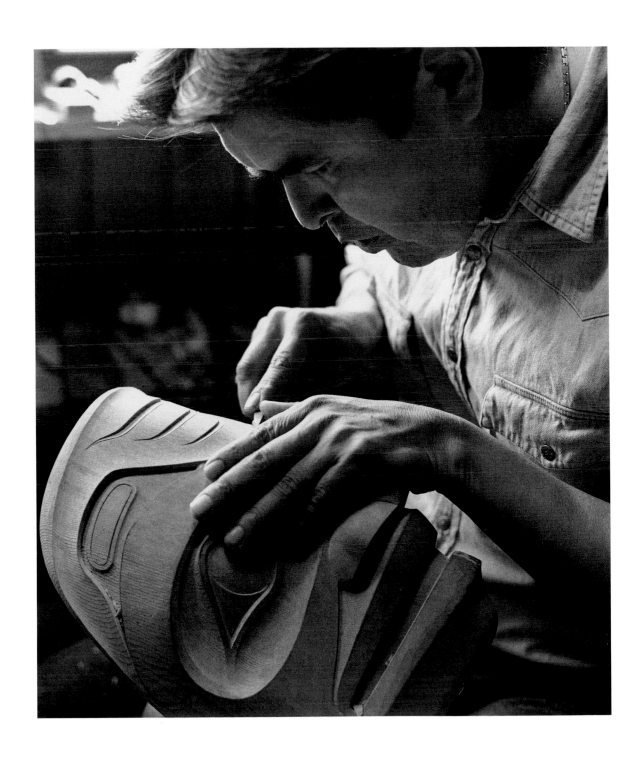

carvings have that jewellery quality which he carried through into all his other media. And when you look at the sculpture of an artist who didn't make jewellery, you can really see the difference. The detail and the high quality and the finish all come from the jewellery experience; it's such a refined artform that if you make the tiniest slip, it shows. You learn to work with a lot more care when you make jewellery, and that care carries over to masks and prints and so on.

Most of my masks are painted with the traditional Haida colours of red, black and blue-green. Sometimes an attribute of the image determines the colour, such as the blue-green colour of the mask of *gagiid*.

My first *Gagiid* mask came from watching a performance before a ceremony. Someone came into the hall, hollering *"7amiiyaa, 7amiiyaa,"* meaning "I saw this spirit thing . . . I'm afraid . . . I found this spirit thing at the end of the village." Then dancers came in, but they weren't anything to be afraid of; that inspired me to carve a mask. Tsinii told me that the *gagiid* is a wild man whose spirit is too strong to die. When I carved the first *Gagiid* mask in 1983, Naanii, who is my cultural critic, said, "I didn't know *gagiid* was so handsome." So I made another one, and then a third. The story about *gagiid* comes from the old days when my ancestors did all their travelling by canoe. If a canoe capsized, a passenger who survived the water and found his way to shore would turn into a *gagiid*. The mask is blue-green to symbolize its cold state from being in the water. The *gagiid* eats codfish, and the spines sticking out around the mouth are the spines from eating the codfish.

There are many masks that I've created that I don't understand to this day, and there are many masks I am creating that don't have a function yet. It goes the other way too – when there's an occasion, I carve the mask for it. For example, when my aunt and uncle died, we had a mourning ceremony for them. The idea for a mourning ceremony came from the black Frog mask that my brother Reg had carved to end the mourning for the Edenshaw longhouse that burned down. I made portrait masks of my aunt and uncle to bring them back from the spirit world, and it worked. People were stunned, they were magnetized by the images. It was eerie, as

though they really had come back. The masks brought to mind incomplete ideas and thoughts about those people, and bringing them back one more time helped us to complete our life with them so that we could let them go. People responded by saying that they hadn't seen that mourning ceremony for a long time.

Sometimes when you do something, it has a connection to the past that you didn't even know about. I feel we are all connected to the past by a thin thread. And when we come together as a group, then those threads form quite a thick rope.

CULTURAL IMAGES

In Haida art, there's a big range of cultural images, a huge selection of crests and creatures. The traditional images fit into several categories. One is the realistic, in which crest images are based on nature and are recognizable as a Dogfish or Eagle or Raven. In classical Haida art, however, the crest images on storage boxes became very abstract, very intellectual, much like classical music. The designs were visually pleasing patterns rather than crest iconography.

Mythology is another category. Mythology was a way of relating reality to knowledge, and experience to lessons. There are many stories about Raven, who is our culture hero. Raven was responsible for bringing houses to the people. Raven was responsible for bringing light to the world. Raven was responsible for assisting the first peoples into this world. Raven wasn't a creator but more of an instigator.

There are fewer stories about Eagle, but unfortunately learning our mythology was not part of my upbringing. The stories that I know are from anthropological sources. My most direct experience with Eagle happened one time when I was at the Yakoun River with Naanii. The Yakoun River is our traditional fishing spot where we go every year to harvest sockeye salmon. This particular day I was working on the salmon with Naanii, when an eagle flew over us. She responded, "That's your uncle." So it's viewed as my uncle because I'm Eagle. Eagle has become

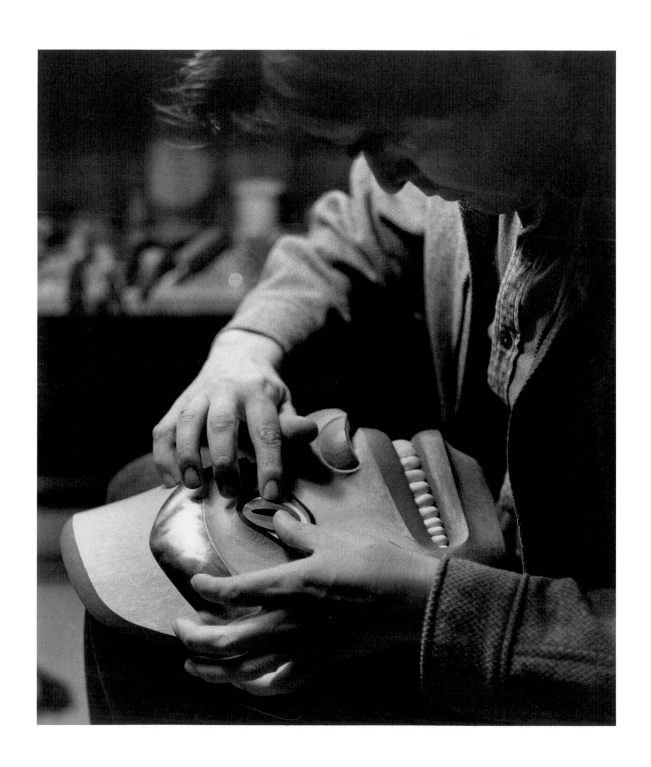

symbolic in my development as a person, and I've started to recognize that part of me.

A third category is the supernatural. There are many supernatural creatures that we can't identify with today, like Sea Bear, Sea Ghost or Sea Wolf. A lot of these creatures do not exist in what we call reality, the real world.

There is a fine line between the supernatural and reality. The way I see it is that the supernatural is in your mind, you're connected to the supernatural through your mind. The artist's role is to make those images real in the form of objects, songs or dances. Some of the foods and skills that were given to the Haida people came to them through dreams. An image would appear to a certain person, and that person became the medium for that image to become real, to express what they saw so that everyone else could see it. This is how the totem pole first came to Haida Gwaii. A man was walking along a trail, and on the path he saw a totem pole. A voice told him to memorize what he saw and to create it and take it back to his village. So he memorized it and started to create it. When he walked on that trail again, the pole was not there.

As the culture developed, more and more creatures were added to the store of cultural images. In the old days, families would adopt new crests and validate them at a potlatch. After contact with the white man, new images continued to be adopted as crests. When the Haida started to paddle down to Victoria, for example, they were introduced to different images, different realities. One new crest that was adopted was the dogwood, which white people had chosen as an emblem of British Columbia. There is a totem pole at one of the villages, Yan, that shows a person took the dogwood as his crest. The Haida people were always adapting. The culture was not fixed, as I had been led to believe by anthropologists. The culture was always evolving with the times.

If there's no creature that seems right for a purpose, then you invent a creature. That's one of the great joys of the artform. In fact there are new creatures emerging in my flat designs. They have no names yet, but they are emerging, and that leads me to believe the artform is developing on

Facing page: *Robert putting in the copper eyes on the Dogfish Mother mask, red cedar, 1988.*

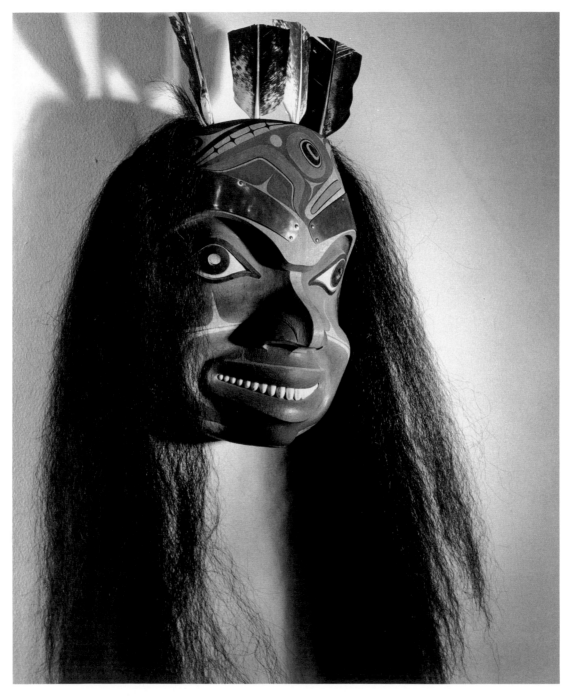

Aunt Portrait *mask (left) and* Uncle Portrait *mask (right), both red cedar, 1987. The Aunt Portrait* mask *has copper eyebrows and feathers; both have teeth of operculum shell.*

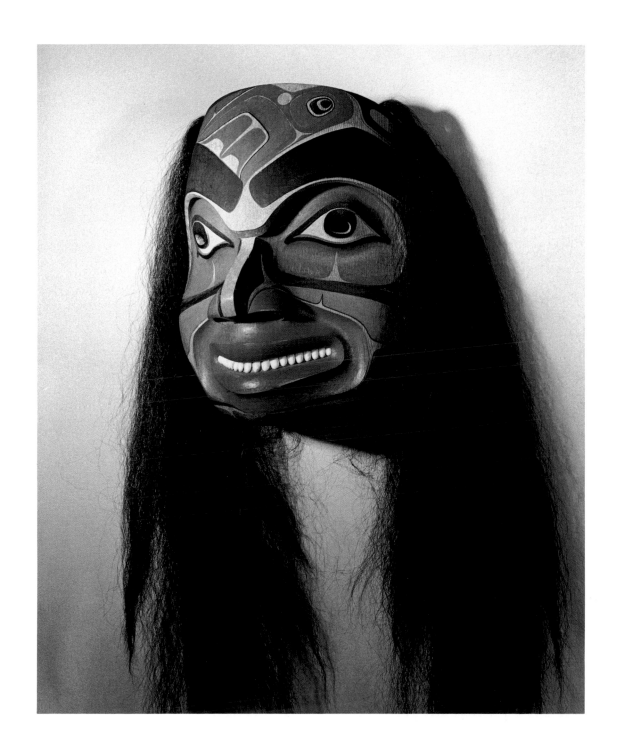

two levels, the subconscious level and the conscious level. Some new creatures appear without my thinking about them; those are from the unconscious level, and I don't know who they are yet. There are other creatures that I deliberately create; those are from the conscious level. For example, I have been working on new spirit creatures like the Spirit of Gossip, the Spirit of Truth, or the Wannabe mask.

NORTHWEST COAST DESIGN

In Northwest Coast art, the formline is the skeleton of the object or of the creature that is being portrayed. The formline is an energy flow that is in constant motion. When I'm drawing lines, each line has its own tension. It's like bending a ruler – I'm creating that tension. And I stop that tension just before it breaks. It's very much like calligraphy.

There are two main alphabets based on two forms or shapes, the ovoid and the U-shape. The ovoid shape looks like an oval, slightly flattened or concave on the bottom. It is traditionally used for eyes, joints in the hands, arms, legs and feet, or to lighten up heavy areas of the design. The U-shape looks like a U. It's used for teeth, ears, cheeks, nostrils, nasal passages, tail flukes, feathers and, like the ovoid, as a space filler.

I sometimes jokingly say that you just keep adding on ovoids and U-shapes until you find a creature. The ovoid and the U-shape can be used to create almost anything within any given space. You can stretch them, pull them, tear them apart, use them as negatives or positives. Just as there are umpteen words you can make out of the twenty-six letters of the alphabet, there are countless variations of the two shapes. You can use the alphabets separately or mix them together. There are formulas that you have to understand and follow in order for the piece to work: if you leave out one part of a composition, it's like leaving out a note in a song – everybody notices.

When I'm drawing a shape, I'm paying attention to three different spaces: the space outside it, the shape itself, and the space inside the shape. Once the formline or skeleton of a creature is worked out, the fun part is to fill in those spaces so that they all relate to each other. It's all about

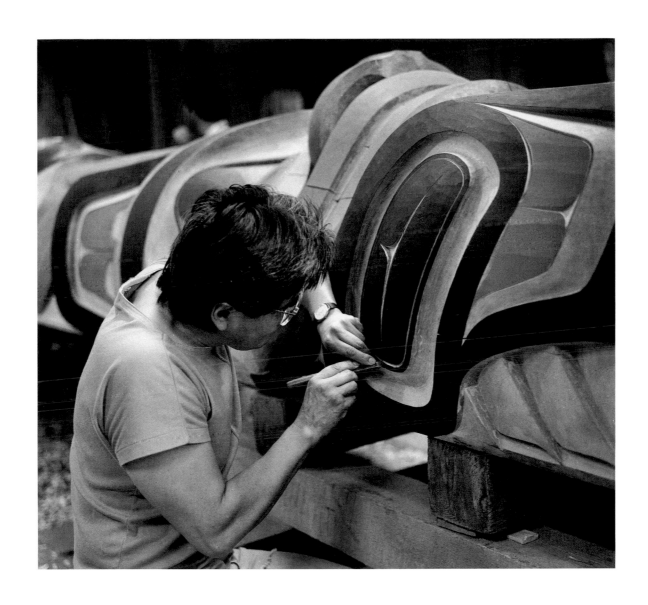

spacing and economy of space. I love to create new shapes and new spaces. I'm constantly calculating the proportion, the composition. Once you become used to working with the forms, you can be more spontaneous. One of the great joys is figuring out how to use one form to help complete another form. There has to be a continuous flow. Some ideas work and some don't. I have a drawer full of ideas that didn't work.

I used to think that the positive space was the important thing, but as I developed I started realizing how important those negative spaces are. When you create a positive space, you're also creating a negative space, and you have to pay attention to both. In order for that image to sing, both positive and negative spaces have to be in balance.

I still study old Haida art. I look at old pieces and I look at masks. I'm still discovering pieces that I didn't know existed when I visit different museums in Germany, Switzerland, New York, Ottawa, Toronto, Seattle, San Francisco, Philadelphia, Washington. When I look at the work of Charles Edenshaw and the other old masters, I can see that they were chuckling with joy when they made those pieces. They took joy in creating elements of surprise. I've studied a lot of Charles Edenshaw's work, and he certainly had a mastery of the artform and culture, one that I can only try to imagine.

I don't confine myself to studying just Haida style. I also look at the work of artists from other Northwest Coast nations. And I enjoy looking at some of the ancient Japanese and Chinese sculptures, the floral designs on European art, some European religious sculptures. It seems as though we all have that dark side and that beautiful side, the wild man and the fairy.

The artform has a very structured formula that makes it Haida art. There are certain conventions that you do an eye this way or a forehead this way or the eyebrows this way, but you still have to create in it the feeling of that Eagle or that Raven. You can't create an eagle or a beaver without knowing what it really looks like. So there is a fine line in the abstraction. I find working in the abstract a lot more challenging than realism.

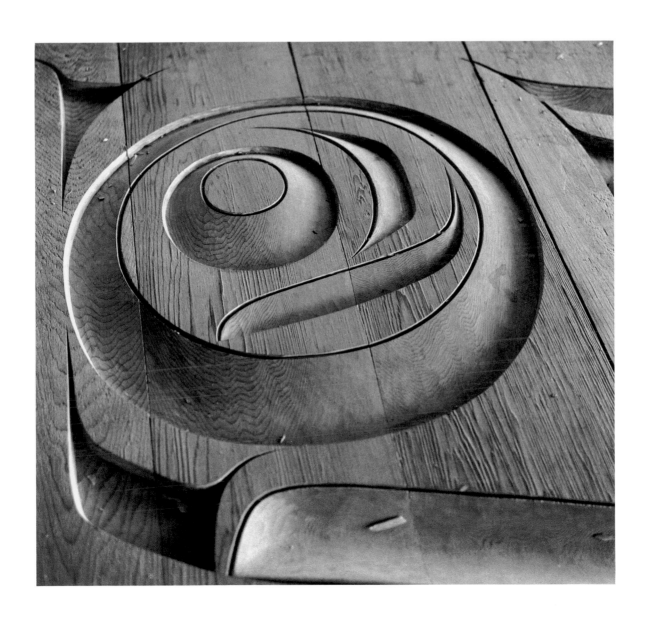

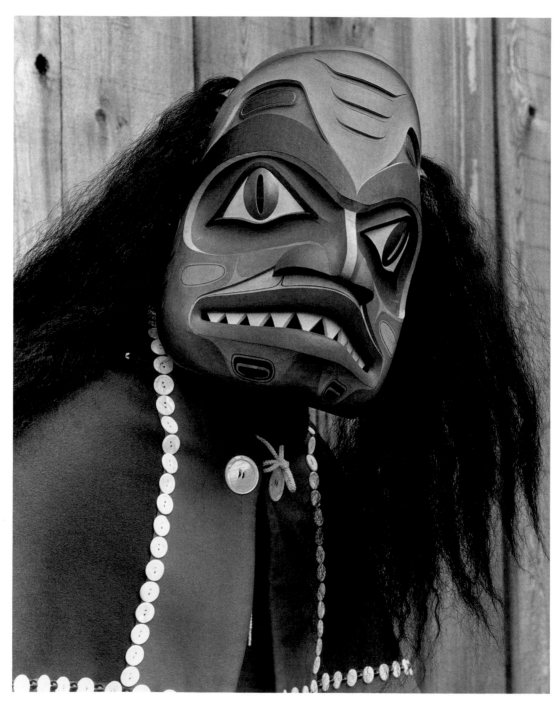

Shark mask, 1988: red cedar, human hair.
This is the same Shark mask which Robert is shown working on earlier.

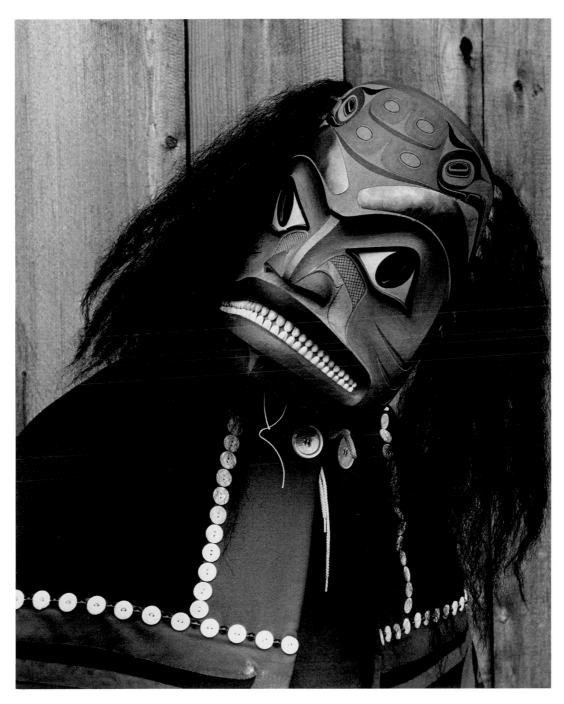

Dogfish Mother *mask, 1988: red cedar, copper eyes and eyebrows, human hair, operculum shell teeth.*

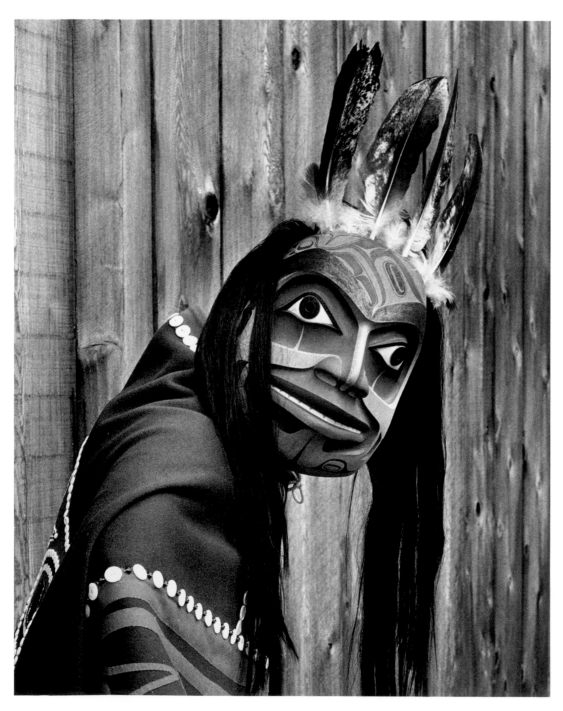

Dawning of the Eagle Too *mask, 1989: red cedar, feathers, human hair.*

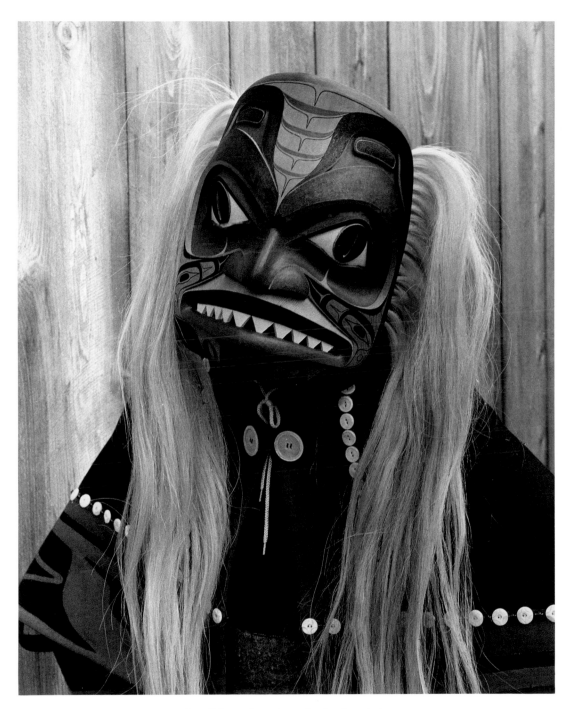

Dogfish *mask, 1989: red cedar, horsehair.*

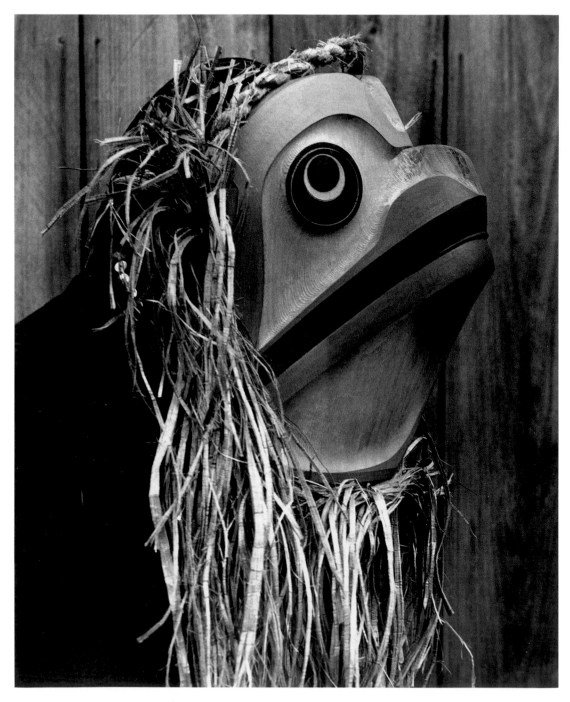

Crab of the Woods (Frog) *mask, 1989: red cedar, cedar bark.*

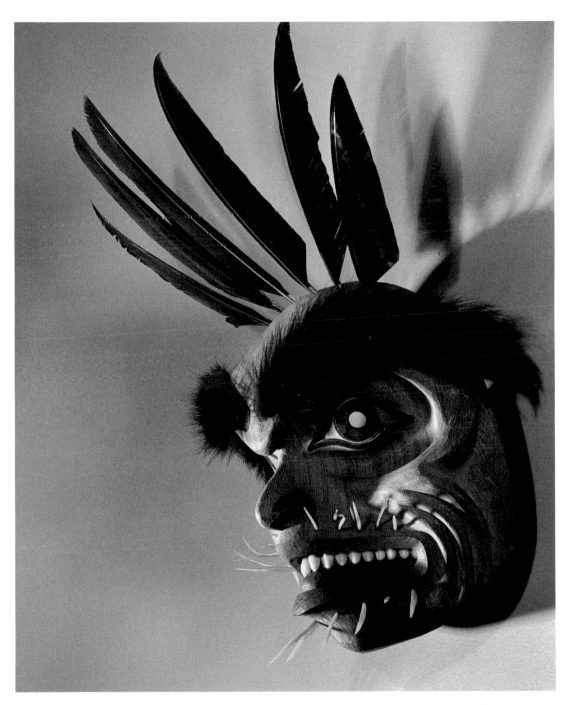

The first Gagiid mask, 1983: red cedar, feathers, bear fur, cod spines, operculum shell.

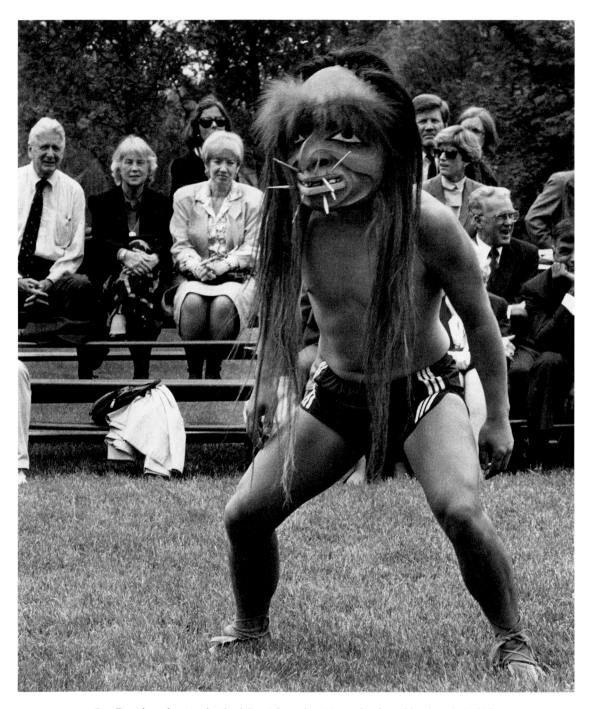

Reg Davidson dancing the third Gagiid mask, 1985: red cedar, alder, horsehair, hide.

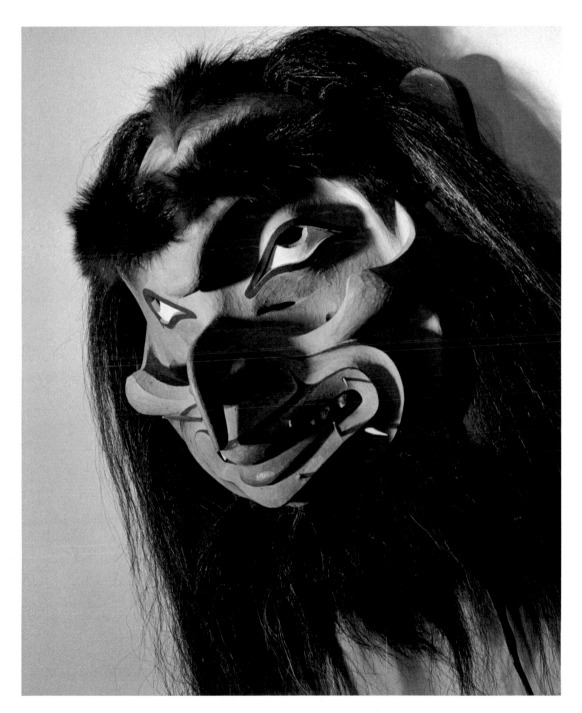

The second Gagiid *mask, 1984: red cedar, human hair, operculum shell, feathers.*

⋮

Chapter 6

MAJOR WORKS FROM THE LATE 1980S

NANASIMGET AND KILLER WHALE, 1987

The people who commissioned the dorsal fin sculpture came to me in 1986 with a story in mind. They knew about one of the Haida legends in which Killer Whale kidnapped the wife of a hunter and, being divers, they wanted a story that was related to their hobby. We called it "the dorsal fin," but the real title of the piece is *Nanasimget and Killer Whale* or *Killer Whale Kidnapping the Wife.*

I enjoy meeting people who come to me with an idea in mind. We get to know each other informally and often I'm able to draw an image right then. So while we were talking about this project, I doodled a dorsal fin on the spot; two men and a wife emerged from that and the base of the fin became the Killer Whale. The clients liked the idea, so I did a more refined drawing for them and also a model.

If you look at it carefully, you'll see the right and left hands of each person wrapped around the fin. There are actually four hands there. The top two hands belong to the husband, and the wife is on the bottom with her two hands. They're both clutching the dorsal fin as though they're being pulled underwater.

The sculpture is six feet tall and took two months to carve.

It's an experiment, a sculpture in the round. I was really excited about it because it goes beyond flat design and is really a sculpture rather than a totem pole, which is meant to be viewed from one side.

SKELETON HOUSEFRONT, 1989

The day after the *Three Watchmen* totem pole was raised, a man walked in and said, "I want one." That happened in 1984. I was busy with other projects, like the Pepsi Cola project, so I had to put him on hold for five years. In the meantime I drew several renditions for him.

I got the idea of doing a skeleton housefront from a visit I'd made just before that to Ninstints, an abandoned village on the very southern tip of Haida Gwaii. It's the most southern Haida village and was abandoned in the late 1800s, but there are quite a few totem poles still standing there

and the remains of houses. What is amazing is that the day before, I'd been in Massett when the Edenshaw longhouse whose front I had carved burned down. It was ironic that I'd watched a new Haida house burn down within two or three hours and the very next day I was looking at ancient houses in slow decay, the odd remaining corner post of a house plus a fallen beam. I was impressed by the strength of that image and thought that it would make a beautiful sculpture, so I stored it in my head. When this client came to me, I suggested the idea of a skeleton of a Haida house because he's a land developer.

On the central pole of the housefront, I decided to show the legend of how Raven brought the house to the Haida people, to make a connection with the client's business. Once, Beaver had owned the house, but Raven stole the idea from him and gave it to the Haida people. The client liked the Three Watchmen on the Maclean-Hunter pole, so each of the two corner posts of the housefront is a Watchman, and the third Watchman is on the very top of the large totem pole in the centre.

The skeleton of the longhouse frames the central totem pole.

The client wanted a 50-foot tall totem pole, so I played with proportions based on that. The corner posts are 24 feet tall, and everything is structured so that it is actually a unit. It was intended to be a composition rather than a house, but it could be turned into a house by adding on the rest of the frame and the walls and a roof. It's a full-size piece that is 24 feet wide by 11 feet high at the centre. It's my tribute to the Haida house.

This piece took six months with two apprentices, Reg Davidson and Glen Rabena. It was a unique, exciting idea, and I didn't really know what it would look like except on paper. When the pieces of the housefront were actually installed, the sculpture went beyond my expectations.

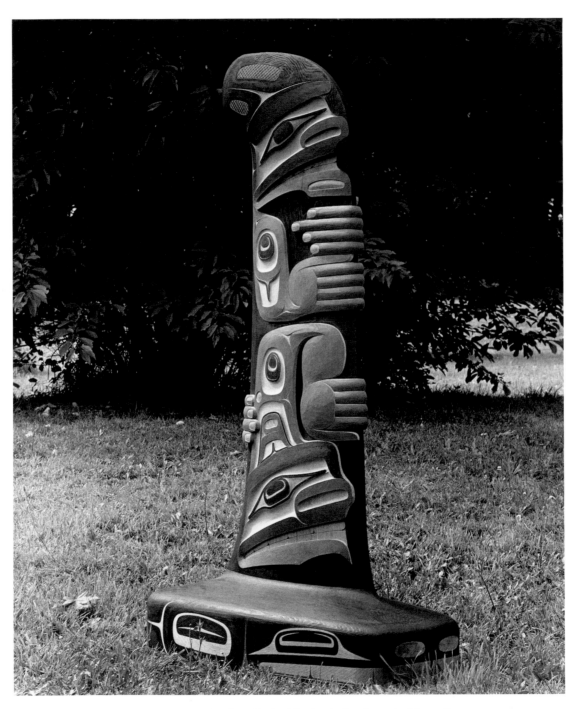

Nanasimget and Killer Whale: *The finished sculpture is 6 feet tall.*
Facing page: *The model is a foot tall. Both are red cedar.*

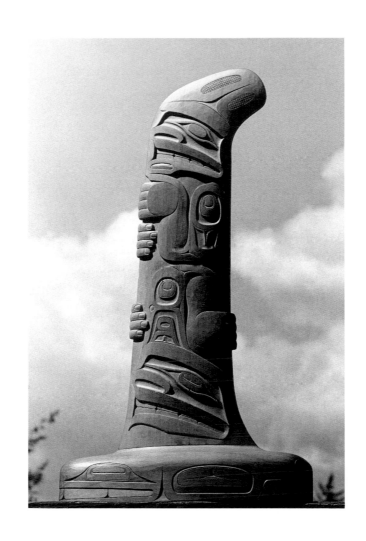

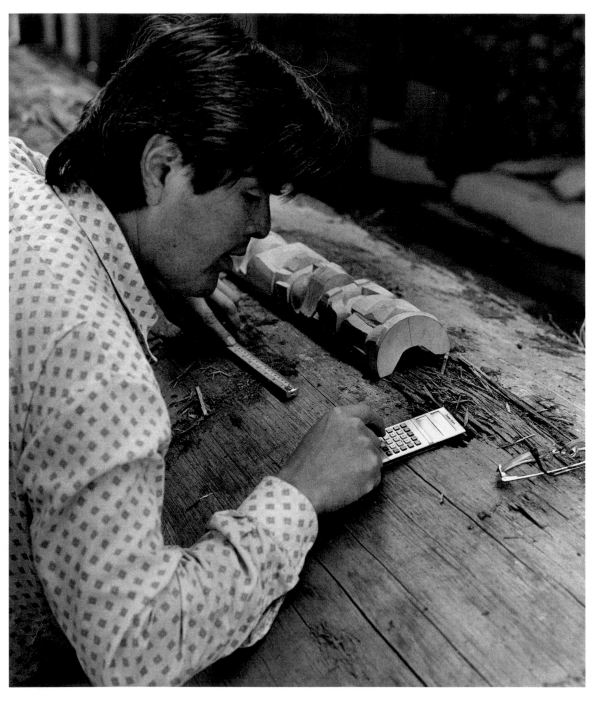

Robert calculating the ratios for transferring design measurements from the model to the 50-foot centre pole for Skeleton Housefront, *1988.*

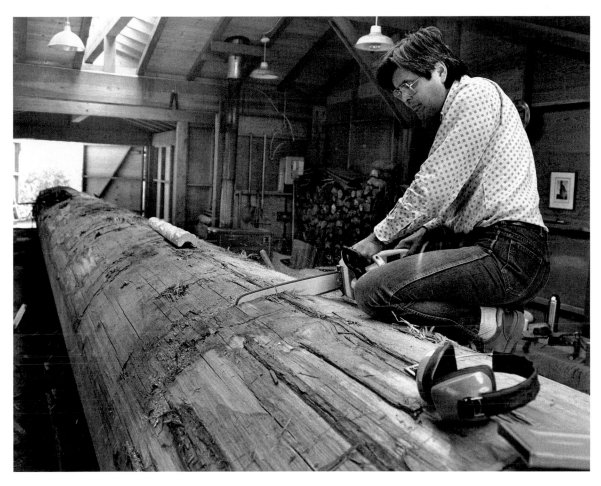

Robert using an electric saw to make the first cut into the centre pole. "I learned from past projects that it wasn't necessary to shape the log as much as I used to, and that saves a lot of time."

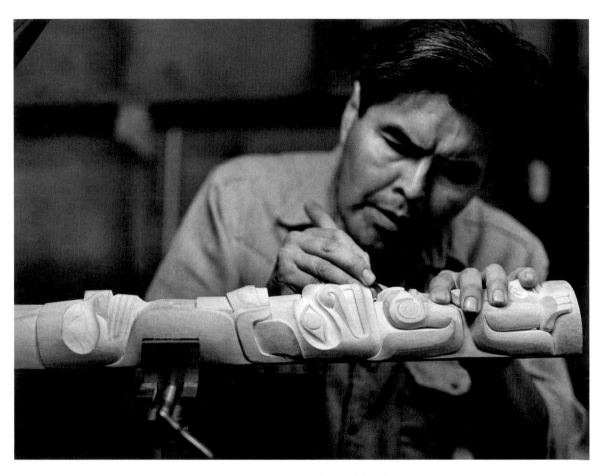

Robert using a knife to refine the yellow cedar model of the centre pole, 1988.

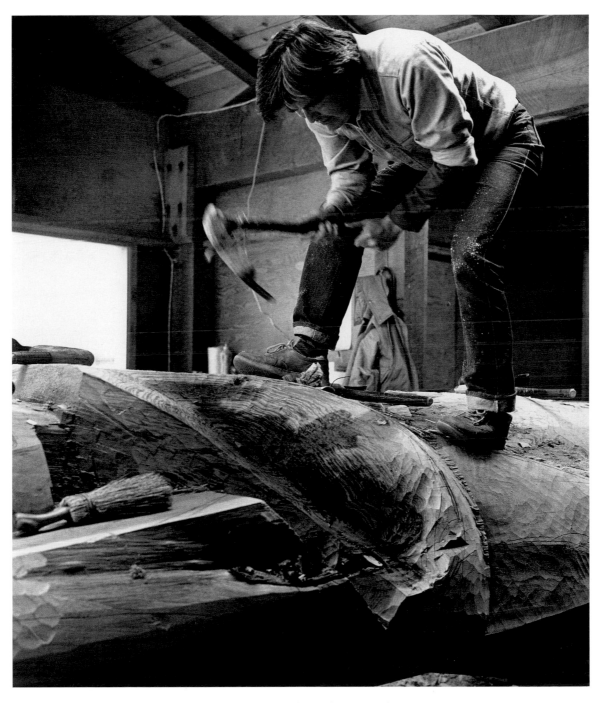

Robert at work with an adze on the centre pole, 1988.

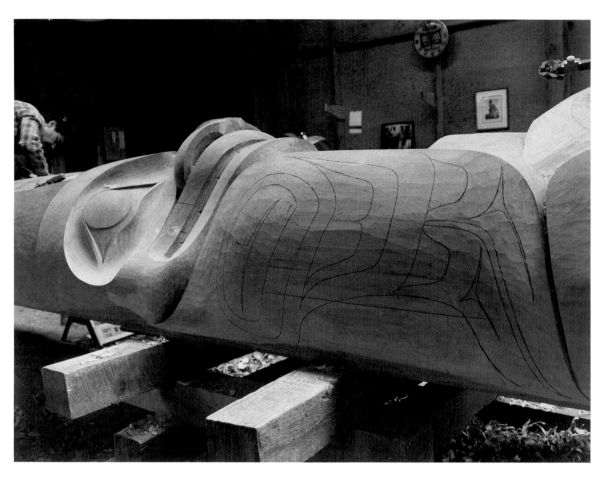

A section of the centre pole, showing Raven in human form.
Above: *The side that apprentice Larry Rosso is working shows the head carved and the rest of the design sketched on.*
Facing page: *The side that Robert has completed carving.*

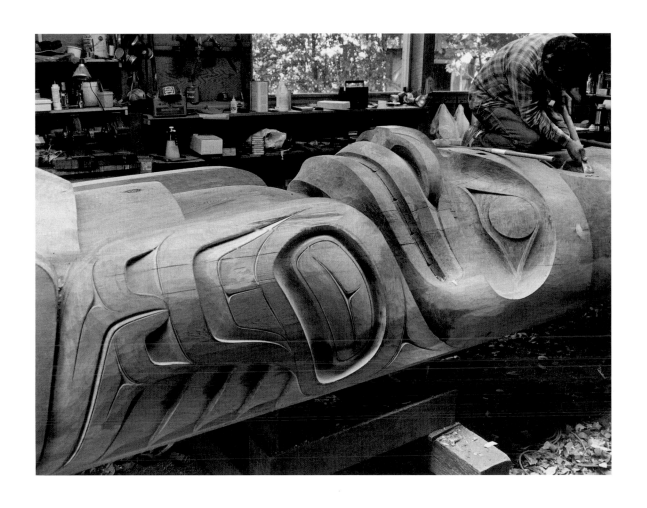

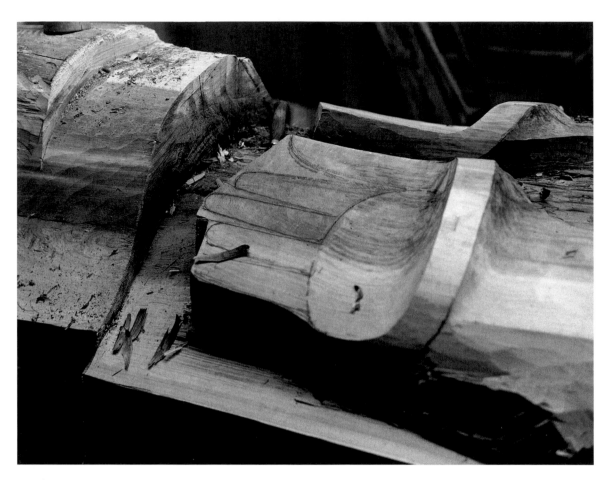

Above: *Close-up of the Watchman's hands, roughed out and ready to be refined, on one of the 24-foot corner posts.*
Facing page: *The yellow cedar models of the two corner posts, a Watchman on each, lying on the finished hands that are shown blocked out in the photograph above.*

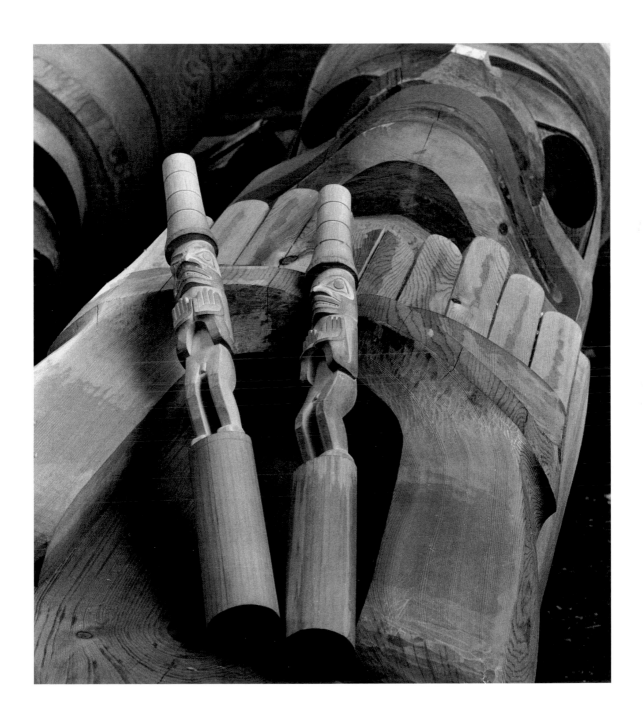

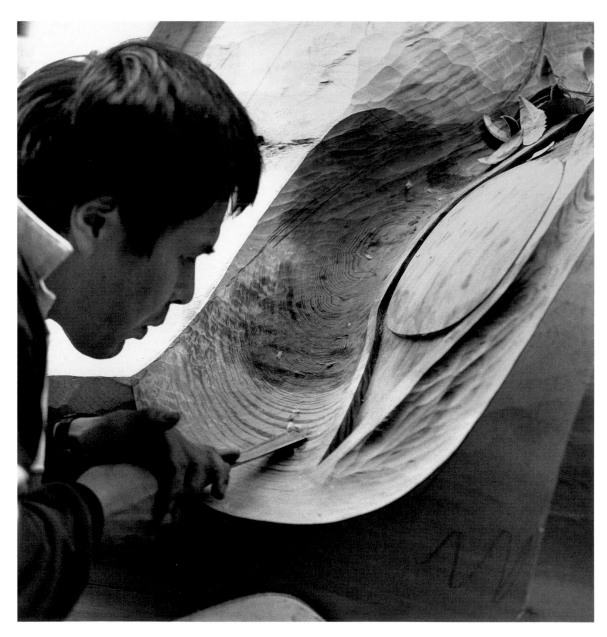

Reg Davidson chiselling away wood on the Beaver's eye on the centre pole of Skeleton Housefront, *1988.*

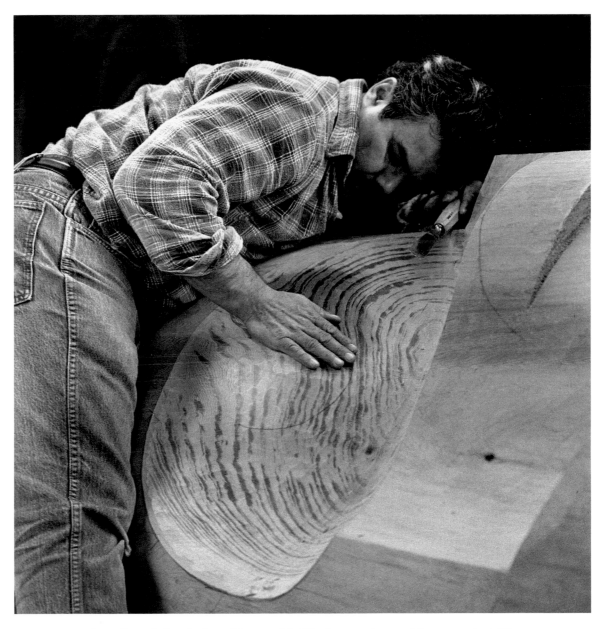

Larry Rosso feeling the form of the eye of the Watchman at the top of the centre pole, 1988.

⋮

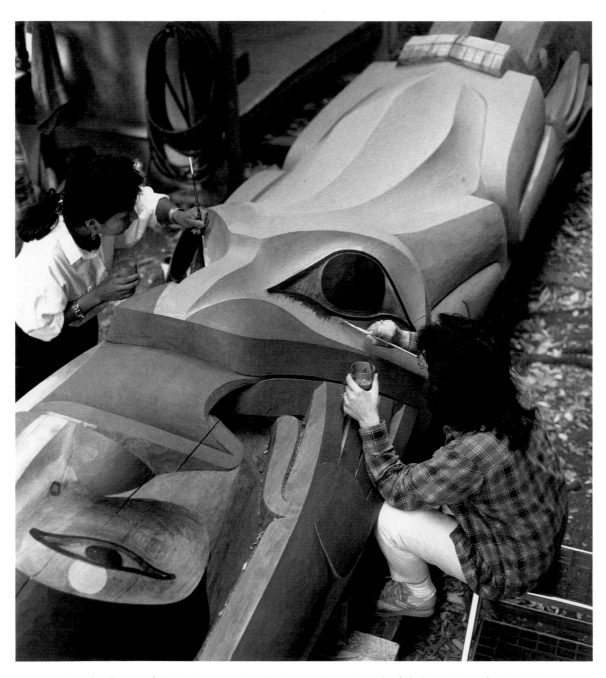

Dorothy Grant and Marie Gregg painting the Frog on the centre pole of Skeleton Housefront, *1988.*

⋮

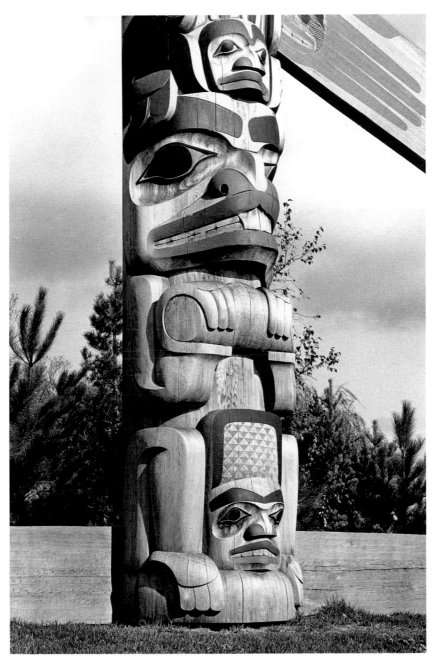

Close-up of the bottom half of the centre pole of Skeleton Housefront, *installed in Toronto. At the bottom is Beaver, with a chewing stick in its forepaws and a face in the joint of its tail.*

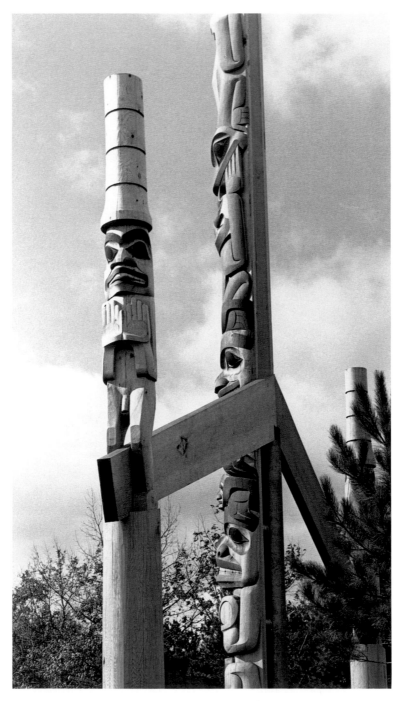

Rear side view of Skeleton Housefront, *set up in Toronto, 1988.*
The house gable beams fit in the notch formed by the
Watchman's legs on each side post.

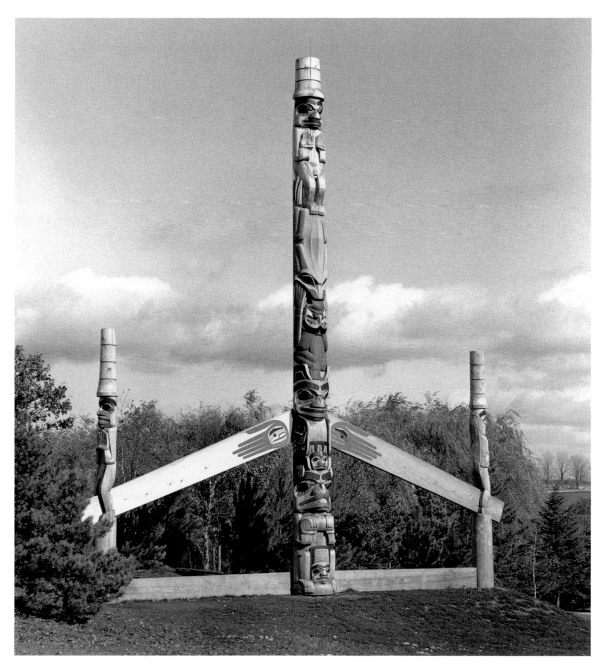

Front view of Skeleton Housefront *in Toronto, 1988. The painted hands on the gable beams are to indicate the human form of the Raven that is carved on the centre pole with wings to indicate its bird form.*

Chapter 7

RECENT WORK

MASKS, 1989 TO THE PRESENT

We are now singing our traditional songs, which have been handed down to us through the generations. There are only a few songs that have survived, but there are enough to set a standard from which we can compose new songs, as our forefathers did. These new songs express who we are now. We now sing a song an old song called "Eagle Spirit." The song is old, but we have created a new dance that expresses who we are today. The image and meaning of that dance is expressed through the red *Eagle Spirit* mask.

My earlier masks don't have a mouthpiece, which is a piece of wood on the inside that you bite into to hold the mask to your face. It's something I learned from the old masks. Now every mask has the mouthpiece, and every mask is intended to be danced. I've tried to make a mask to be just hung on the wall, but I can't. That mouthpiece always has to be in there. Sometime we carve and paint a mask without a mouthpiece, but we end up saying, "Yeah, put it in. It's part of the mask."

When I made the *Salmon* mask in 1989, it was to honour the salmon, which is our staple food and has a lot of meaning in our culture. Every year we go back to our traditional fishing spot at the Yakoun River to harvest salmon: preserve it, dry it, freeze it, eat it, give it away. That experience is sacred, and I've always wanted to pay tribute to the salmon. I do it in my own private way, thanking the river as I'm leaving, thanking the trees, thanking the salmon, but I wanted to express it on a broader scale, and that's how the *Salmon* mask came into existence. The ceremony is not to ensure that the salmon come back but to give thanks and to give back something. When that *Salmon* mask was being danced and songs sung, the old people said, "I haven't seen that for a long time." We were connected to that ceremony which had happened in the past; we didn't make it up. It happened before, and we were re-enacting it.

After I started carving more masks, the experience affected the way I carved the totem poles. I would push the totem pole further, then go back to the mask and push it a little further. The Salmon on the *Two Eagles* pole

has influences from the *Salmon* mask that I made. The same with the Eagle on that pole – the head has feelings from my *Eagle* masks.

The masks are getting larger because we're dancing in bigger halls and I want to create an effect, create a feeling. If we use life-size masks, these little masks, then someone who's 50 or 75 feet away can't see much. When I sit in the audience and watch other performers dance to study movement and presentation, ideas come to me on how to improve our presentation.

Transformation masks are another way of creating magic, of creating an effect to hold the audience in awe. You can only carve one expression on a mask, so the transformation mask, which opens out to reveal another mask inside, is the next level.

I didn't study any transformation masks before making one, though I'd seen several. In stories about transformations, beings are always turning into something else. Eagle into Human. Or Human into Raven. Or Wolf into Killer Whale. Another influence was speeches I heard when I was growing up, in which someone would talk about so and so, and how we should follow his or her way because he or she was a good role model. That idea bothered me. What's the matter with who we are? Why do we have to be like someone else?

That led me to think of transformation as becoming yourself, becoming who you are. The image of Eagle transforming into itself came to me; what's interesting is that Eagle is my crest. It was also a time when I was starting to look inward. I believe I'm becoming Eagle, I'm becoming myself. Then I made the transformation mask called *Eagle Transforming into Itself.* It's me becoming who I am. So the mask is a modern statement rather than a traditional one.

Many of my recent creations have Eagle as a theme: many masks, especially *Eagle Transforming into Itself,* many prints and paintings of Eagle, drums with Eagle on them. Some artists go through a blue period or a black period, but I went through an Eagle period.

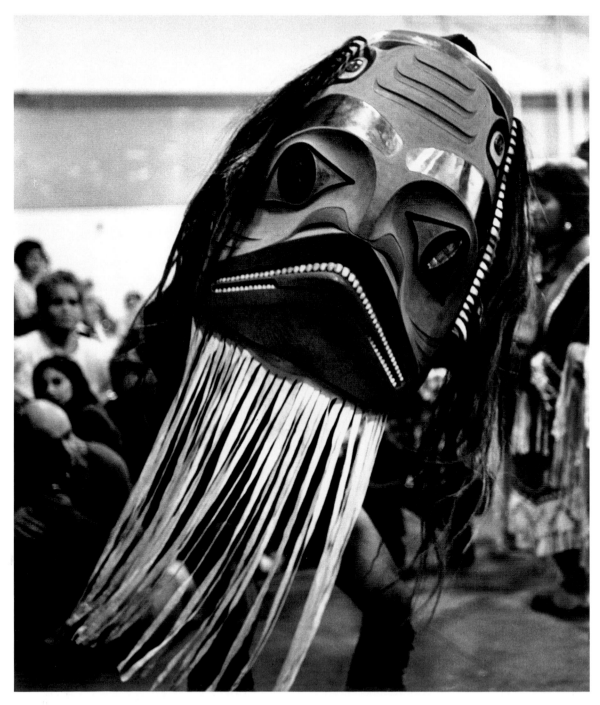

Dogfish Mother *mask, 1986: red cedar, horsehair, leather, copper and operculum shell. This is one of Robert's very big masks. He is dancing it here at the 1986 potlatch at which his father, Claude, was made a chief.*

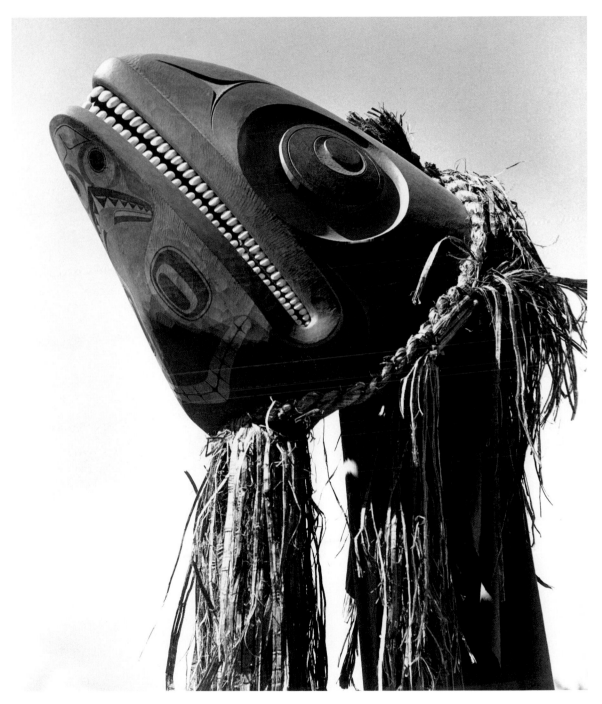

Spirit of Salmon *mask, 1990: red cedar, cedar bark. Another very big mask.*

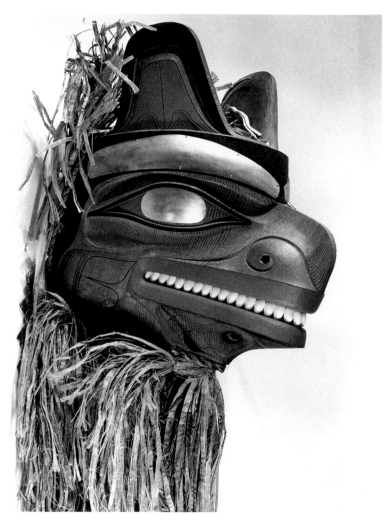

Wolf *headpiece, 1992: red cedar, cedar bark, copper eyes
and eyebrows, operculum shell teeth.*

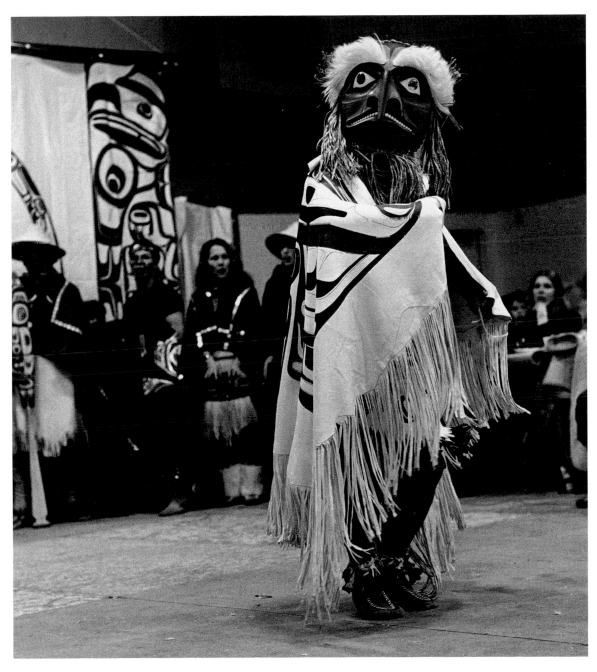

Reg Davidson dancing Robert's second Eagle Spirit *mask at the memorial for their father, Claude Davidson, at Massett in October 1991.*

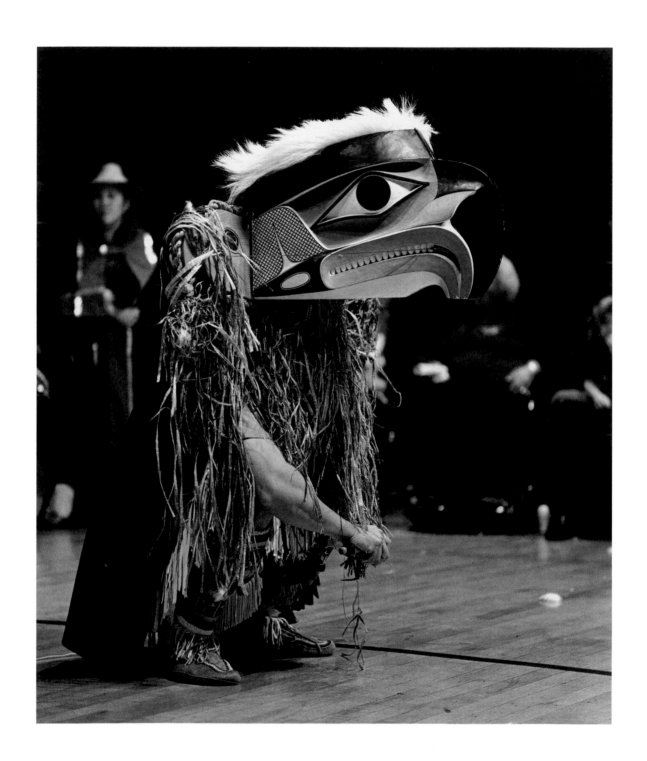

140

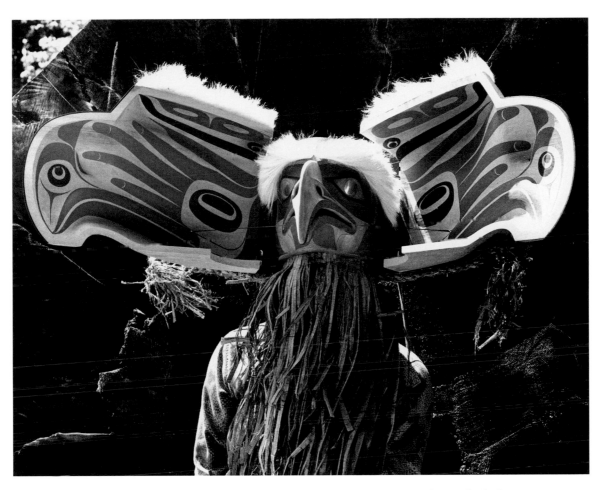

Eagle Transforming into Itself mask, 1990: red cedar, goat hair, operculum, cedar bark.
This transformation mask opens to reveal another Eagle inside.
Above: *The mask when it is open.*
Facing page: *Robert dancing the mask (closed) at the "Urban Feast" for the*
urban Haida which he co-hosted in Vancouver, 1993.

BREAKING THE TOTEM BARRIER, 1989

The client who approached me in 1988 to carve this pole worked for Pepsi Cola and had some other sculptures in his yard. After talking with him, I presented some ideas, and he really liked the one for a totem pole in the round. The collectors and myself both have to be happy since they have to live with the creation. The title of this sculpture, *Breaking the Totem Barrier,* speaks for itself, because it is going beyond the idea of a totem pole with a flat back.

One of the things about carving totem poles is that the process of development has not stopped. Bill Holm described old totem poles as two-dimensional carvings wrapped around a pole. Some artists went beyond that wraparound two-dimensional style, especially on the argillite model poles which became more and more sculptured. Once I grasped that I also started pushing the concept and ended up with a freestanding 360-degree sculpture in the round, as opposed to a log with one third cut off and carved on one side.

I'd thought about the idea of a pole in the round for a long time. It would be easy to carve two totem poles and put them back to back, but I didn't want to do that. The real challenge was to have the whole piece integrated. I designed the front and back in relation to each other. Because I was dealing with all sides instead of just one side, I ended up with a lot of odd shapes. When you're designing, you're creating shapes, so a full round pole is different from a flat back totem pole, on which you don't have to deal with those other spaces because you cut them off. On a round pole you can't hide anything the way you can with a flat back pole.

The concept was unique, so we had to deal with things differently. We chose a log that already had some of its centre removed and removed as much more of the centre as possible to let air in so the pole would dry evenly. The brackets to anchor the pole and to allow us to turn it so we could carve in the round were made by Earl Carter and Kevin Helenius. They placed a beam right through the hollowed out centre and put brackets on the top and bottom. They built a frame to accommodate the beam; it was supported at both ends, so we could turn the pole. They also

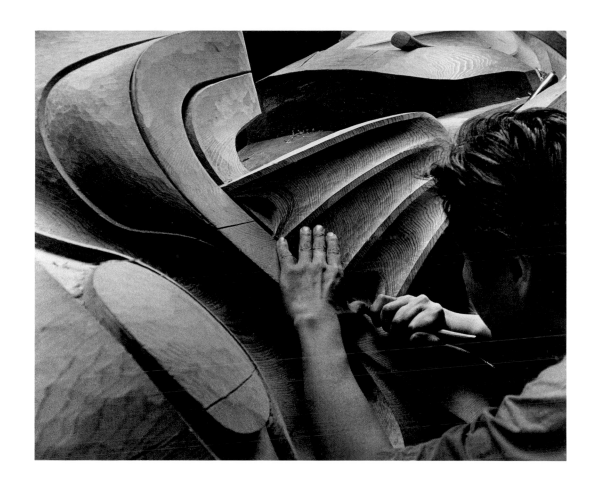

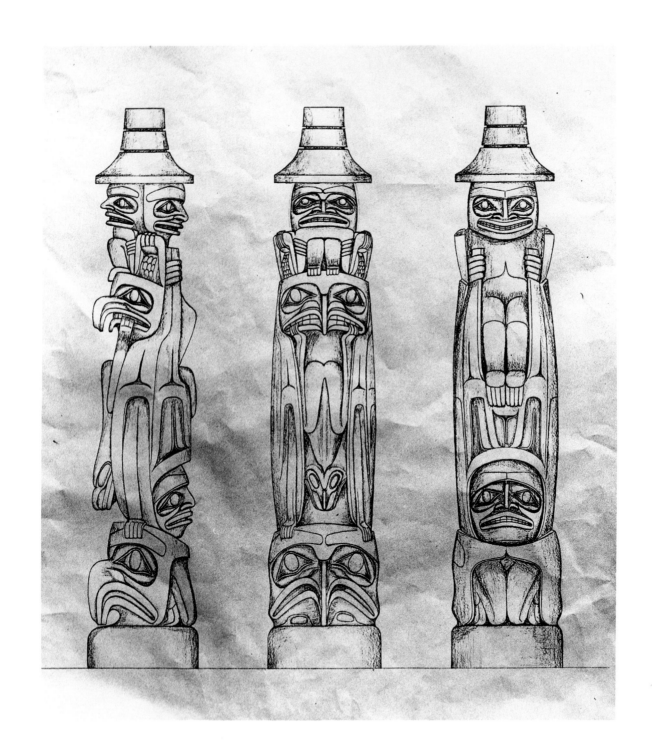

came up with solutions on how to square the pole and how to hollow it with a power saw. Then they built a special frame to transport it, since it was carved all the way around.

On the front of the pole, at the very bottom, is an Eagle head, to symbolize the American client. As you look up the pole, you see the Eagle's wings going up most of the length of the pole. Above the Eagle's head is a Frog, then a second Eagle head. What's fun is that the hind feet of the Frog are coming through the U-shape, a feather shape, in the wing of the Eagle; the U-shape serves a double purpose as the feet of the Frog and as the arms and hands of the wife on the back side.

At the top of the front is a Watchman perched in the Eagle's tail, which has three feathers. The two side feathers are the feet of the Eagle coming through the feathers and clasping the feathers. The middle feather of the tail has the feet of the Watchman coming through.

On the back of the pole, at the bottom, is the face of a woman, in the joint of the Eagle's wings. In Haida art, joints sometimes have human faces; like an X-ray, you can see the ball and socket of that joint. The artist is free to fill that space in any way he wants to, from a simple ovoid to a very complex human face. In this case, I used that space for the face of the wife; her feet come through the back of the Eagle's head, which is cut out to expose them. Above the wife is another Watchman.

The two Watchmen at the top, their heads back to back, share the same hat. Those two Watchmen are actually the two children of the customer. That was the occasion of some humour. When the totem pole arrived at their house, it was all wrapped up, and the boy was really curious. He asked, "How am I supposed to know which one is me?" I said "You'll know tomorrow," because I'd carved him as a naked male. After the pole went up, showing him in all his glory, he was embarrassed. He was really blushing as if that were him up there.

The pole is 20 feet tall, 4 feet wide at the base and tapering to 30 inches wide at the top. Reg Davidson and Larry Rosso worked on it with me. Each project is an experiment and has its own lesson – I'd like to try another pole in the round to see what more I can do with it.

Facing page: *Robert's pencil on paper sketch of the side, front and rear views of* Breaking the Totem Barrier, *1989.*

:

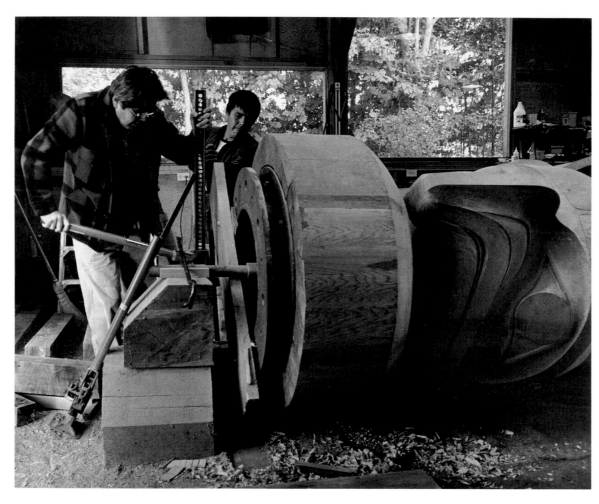

*Robert and Reg using Earl Carter and Kevin Helenius's special invention to turn the pole
so that they can carve it in the round, 1989.*

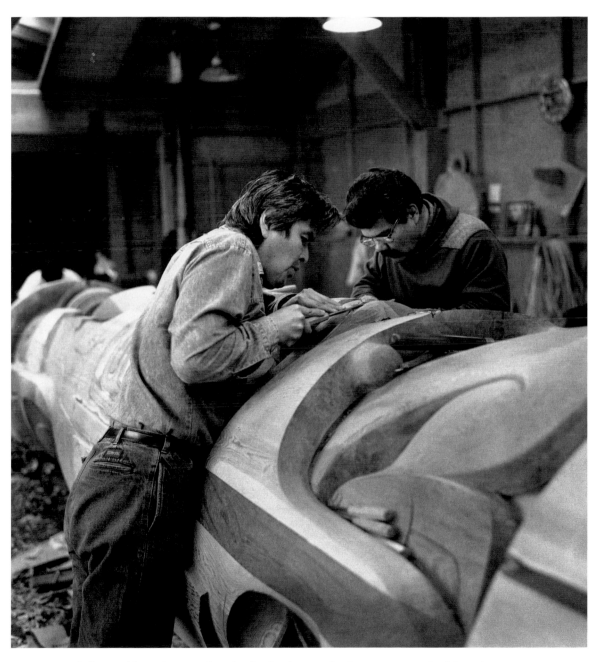

Robert and Larry Rosso working head to head, using chisels to carve one side of the pole, 1989.

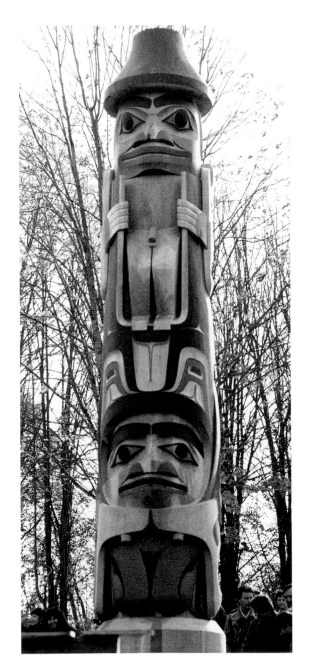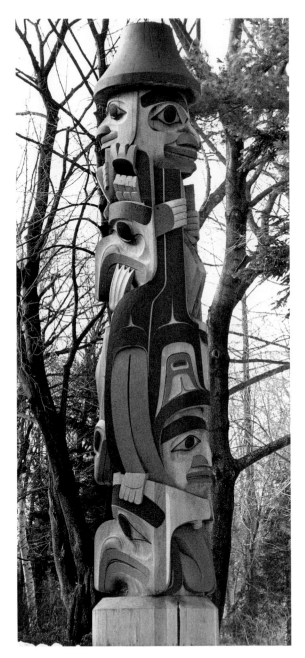

Breaking the Totem Barrier installed on site in New York State. The rear view of the pole at the raising in 1989 (left) shows the Watchman representing the client's son; the side view of the pole some time later (right), and the front view of the pole (facing page) show the Eagle that represents the client.

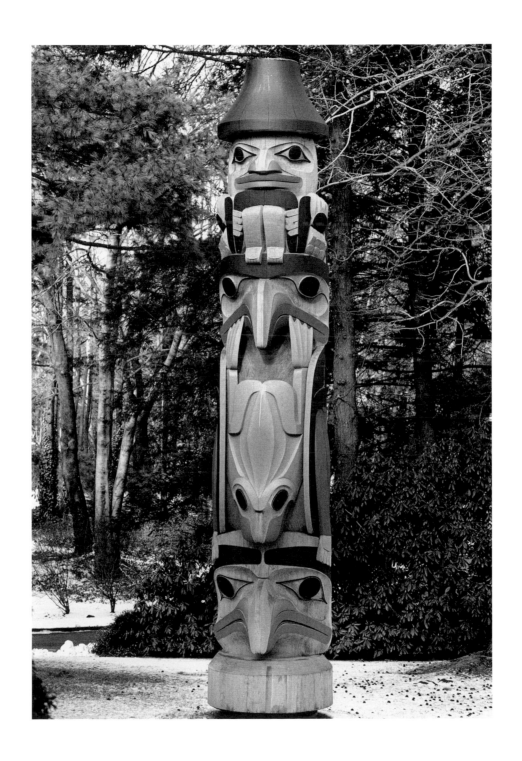

THE *TWO EAGLES* POLE, 1990

The *Two Eagles* pole is another privately commissioned piece that illustrates the family unit of the client, his wife and their two children. When the clients built their house, they made space for a totem pole or a sculpture in the entrance hall. I met them by chance at a function given by one of the galleries that I deal with. We talked about their new house, and they mentioned that they had been thinking about a totem pole. We began talking about an idea for them, and I made some drawings. He's an avid fisherman who also loves eagles and loves his cars. I chose images that would appeal to his character.

Sitting on the bottom of the pole is Eagle, whose wings go up the pole, and above the Eagle is a Salmon whose head is part of the Eagle's wings. The eyes of the Salmon are the joints in the wings of the Eagle. As the wings go up the pole, they form the tail of the Salmon. The second Eagle is the wife, who is tongue to tongue with Frog.

The Frog was not part of the original concept, but when I was carving the totem pole, the Frog appeared. It's almost as though we couldn't chop it out. That's one of the surprises that we sometimes run into when we transfer a design from a flat drawing to a sculpture: spaces appear that weren't there in the flat. So the Frog emerges from the head of the Salmon. It demonstrated to me that the spirit helper has to be there. The Frog, after years and years of my working with it, has come to symbolize my spirit helper. A spirit helper is really your heart. When you follow your heart, then all the doors open. And your spirit helper is there to make things happen for you.

The Frog wasn't part of the budget, but I threw it in anyway. It actually took the longest of all the creatures on that totem pole to carve because it had many undercuts and it was very sculptural.

The hands of the wife, the top Eagle, are tucked in between the two feathers of its wing, under one feather and over the other feather. So the wife's hands are hanging onto the tail of the Salmon or her own Eagle wings, depending on how you view it.

On the very top are two Watchmen, and they are actually the client's children. One has a kind of a grinning smile and that is the daughter, who is very shy. Both children are emerging through the tail feathers of the bottom Eagle. The top Eagle is the joint in the tail of the bottom Eagle. The legs of the two children come through the two side tail feathers, and the Eagle's feet come through the feathers too. The very middle tail feather is jokingly called "the Cobra" for the client's love of his cars.

The pole fits snugly into the entrance hall; there's only six inches of clearance between the top of the pole and the ceiling. The tricky job of installing and anchoring the pole was done by Earl Carter and Kevin Helenius, who have a knack for moving big pieces of wood.

I estimated it would take three months to carve the pole, which is 17 feet high, but it took a month longer because of the Frog that emerged during the process. This pole was carved with the assistance of John Livingston and Larry Rosso. One of the great joys of working with apprentices is to watch their progression. I hired Larry as a journeyman this time, and it was great to work with him again and not have to explain all the processes. John Livingston is an artist in his own right, and it was a treat to work with him because of his experience and knowledge of the artform.

Haida art has become very addictive to me. I feel that its possibilities are limitless, and I've chosen to stay within the artform for that reason. I feel comfortable in saying that I have reached the level where my forefathers left off in the development of the artform. In reaching the level of their achievements, my work has just begun. In reaching the outer limits of the artform, I have a greater sense of freedom. One time I was visiting with my uncle and aunt, and she was laughing at my uncle, saying, "Sometimes I don't understand what your uncle is saying when he talks Haida. Sometimes I think he is just making it up!" He looked at her quickly and said, "You're allowed to."

The 17-foot Two Eagles pole,
carved in 1990 and raised in the
hall of the collector's home in
Vancouver. The pole must be
photographed in two parts
because of the way it is placed.
This page: The bottom part
of the pole.
Facing page: The top part
of the pole.

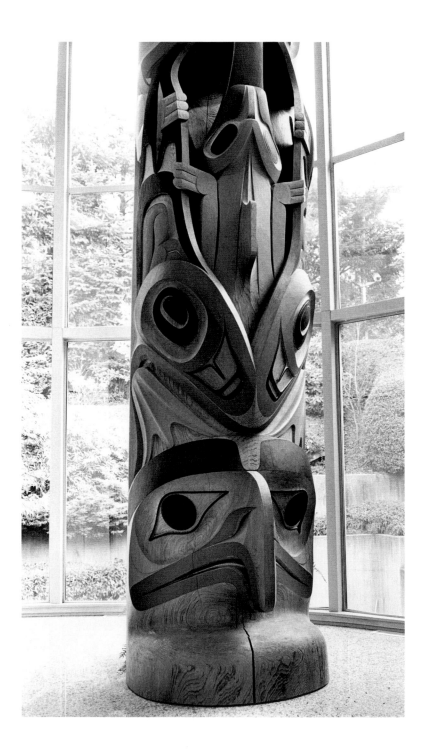

152

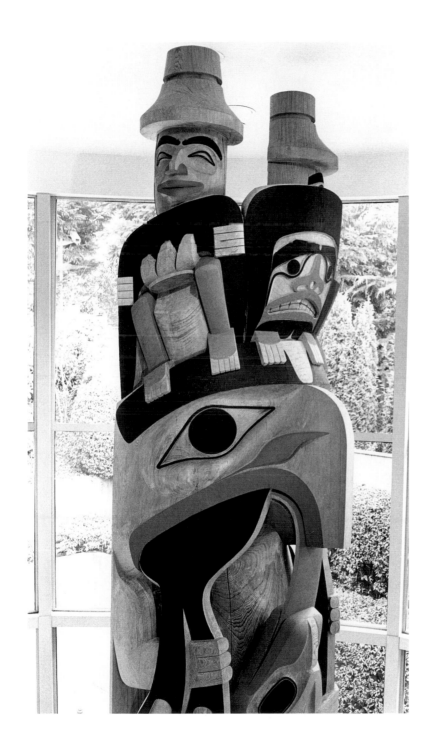

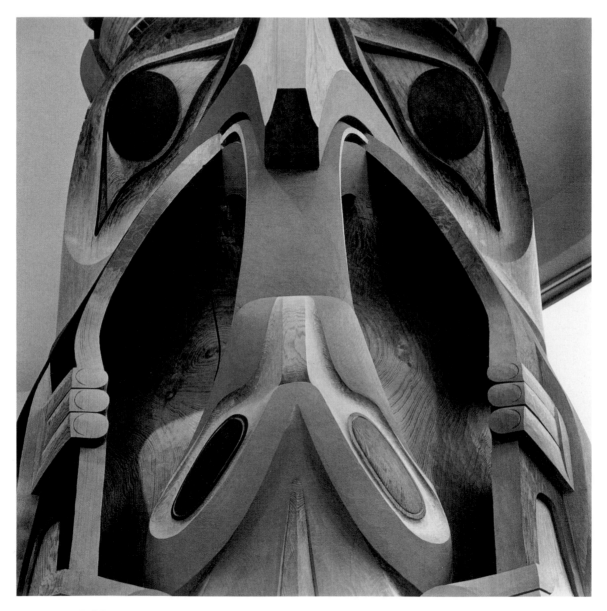

A detail of the Two Eagles pole, showing the Frog ("my spirit helper") sharing a tongue with the Eagle, 1992. One photograph (above) shows the front view, and the other (facing page) the side view. The hands of the Eagle are hanging onto the second Eagle's wings, which also form the tail of Salmon.

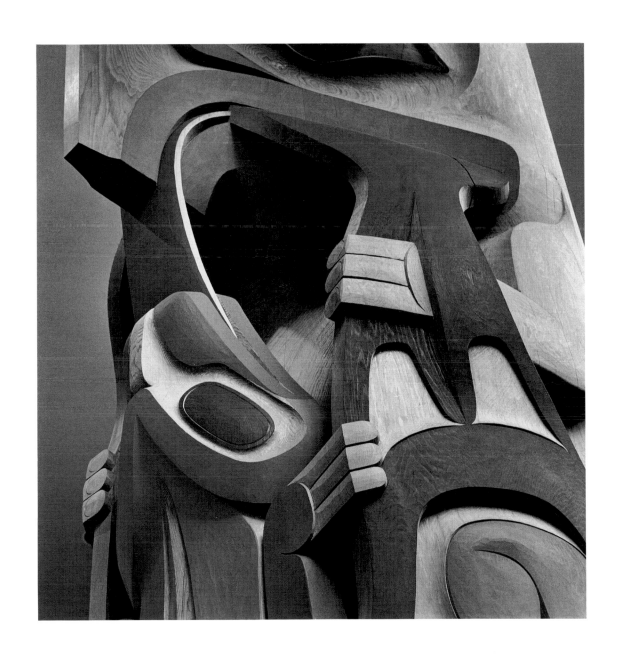

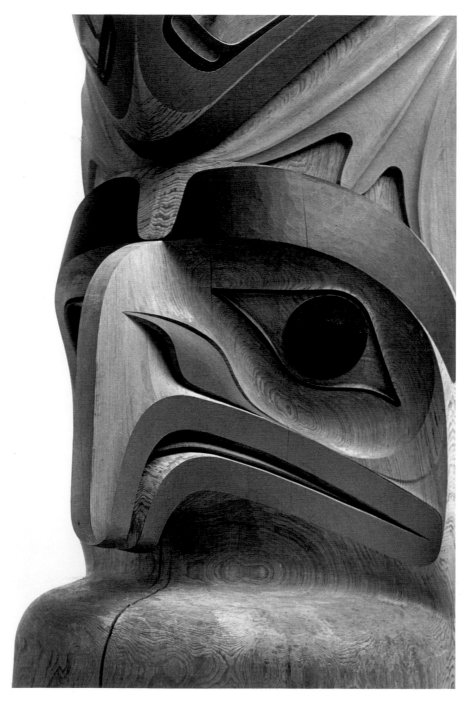

The bottom Eagle on the Two Eagles pole, *1992.*

CHRONOLOGY

1946
► Born Robert Charles Davidson on 4 November in Hydaburg, Alaska, the home village of his mother, Vivian Anniskette.

1947
► Family moves to father Claude's home village, Old Massett, on Haida Gwaii (the Queen Charlotte Islands) off the northern coast of British Columbia.

1959
► Begins carving, taught by his father and his paternal grandfather, Robert Sr.

1965
► Moves to Vancouver, British Columbia, to complete high school. Studies Haida art in local museums.

1966-67
► Apprentices with Bill Reid.

1967-68
► Studies at the Vancouver School of Art (now the Emily Carr College of Art and Design).

1968
► Teaches carving at the Gitanmaax School of Northwest Coast Indian Art in 'Ksan, northern British Columbia.

1969
► Marries archaeologist/curator Susan Thomas.
► Carves and raises the 12.2-m (40-foot) Bear Mother totem pole in Massett.
► Attends Vancouver School of Art, 1969 to 1970.

1970
► Demonstrates carving a 3-m (10-foot) totem pole in Montreal, Quebec, and presents it to the City of Montreal.
► Demonstrates carving a 3-m (10-foot) totem pole in Dublin, Ireland, and presents it to the Republic of Ireland, which gives it to the City of Dublin.

1971

► Has his first solo exhibition in the gift shop of the Centennial Museum (now the Vancouver Museum) in Vancouver.

► Moves to Whonnock, near Vancouver, where he builds a studio.

1972

► Demonstrates carving in Bern, Switzerland.

1973

► Collaborates with Bill Reid in carving a 3.7-m (12-foot) pole for Walter Koerner.

1976

► Commissioned by the Canadian Broadcasting Corporation to carve a screen for its offices in Vancouver.

► Commissioned by the North West Cultural Society to design a a coin with a Haida motif for its Indian Heritage series.

1976-77

► Assists Bill Reid in carving a 12.2-m (40-foot) frontal pole for the Skidegate Band Council office on Haida Gwaii.

1977

► Is a founding member of the Northwest Coast Indian Artists Guild.

► Commissioned by Parks Canada to design, carve and paint the housefront of the Charles Edenshaw Memorial Longhouse in Massett.

► Ends first marriage.

1978

► Carves four 4-m (13-foot) interior house posts for the Charles Edenshaw Memorial Longhouse, with the help of eight young Haida apprentices.

► Has a one-man show at the Bent Box Gallery, Vancouver, B.C.

1979

► Has his first retrospective print exhibition at the University of British Columbia Museum of Anthropoogy in Vancouver.

► Publication of the book *Robert Davidson, Haida Printmaker* by Hilary Stewart on ten years of his prints.

1980

► Begins collaborating with Haida artist and designer Dorothy Grant in the design of Haida ceremonial clothing such as button blankets and dance aprons.
► Sponsors a four-day celebration, "Tribute to the Living Haida," in Massett.
► Helps to form the Rainbow Creek Dancers to perform traditional and contemporary Haida songs and dances.

1981

► Charles Edenshaw Memorial Longhouse destroyed by fire.
► Sponsors a potlatch, "Children of the Good People," in Massett.

1983

► Has a one-man show at the Faschwerk Gallery in Bad Salzuflen, West Germany.

1984

► Carves the *Three Watchmen* totem pole, commissioned by Maclean-Hunter for its building at College Park in Toronto, Ontario.
► Commissioned by the Catholic Church of Vancouver to carve a talking stick for presentation to Pope John Paul II.
► Teaches an advanced course in Northwest Coast totem pole design in Ketchikan, Alaska.
► Commissioned by PepsiCo to create a large *Frog* in bronze for its International Sculpture Park in Purchase, New York.
► Commissioned by the National Museum of Man (now the Canadian Museum of Civilization) to create *Raven Bringing Light to the World* in bronze.

1985

► Commissioned by PepsiCo to carve a group of three totem poles, *Three Variations on Killer Whale Myths,* for its International Sculpture Park in Purchase, New York.
► Moves to Surrey, near Vancouver, and builds a studio/carving shed on the Salish Reserve in White Rock, near Vancouver.
► Marries Dorothy Grant.

1987

- ► Begins collaborating with Dorothy Grant in creating appliqué designs for her line of nonceremonial clothing.
- ► Carves the privately commissioned *Nanasimget and Killer Whale* sculpture for two collectors in Vancouver.

1989

- ► Installs the privately commissioned *Skeleton Housefront,* consisting of a 15.2-m (50-foot) central pole, two house posts, and connecting roof beams, for a client in Toronto.
- ► Carves a privately commissiioned 6.1-m (20-foot) pole, *Breaking the Totem Barrier,* for a collector in New York.
- ► Hosts a two-day feast, "Every Year the Salmon Come Back," in Massett.
- ► Has a one-man show at the Inuit Gallery, Vancouver.

1990

- ► Privately commissioned to carve a 5.2-m (17-foot) totem pole, *Two Eagles,* for the interior of a house in West Vancouver, B.C.

1992

- ► Awarded an Honorary Doctorate in Fine Arts by the University of Victoria, Victoria, B.C.
- ► Has a one-man show at the Gallery of Tribal Art, Vancouver.

1993

- ► Has a major retrospective exhibition at the Vancouver Art Gallery, Vancouver, which travels in 1994 to the Canadian Museum of Civilization in Hull, Quebec.
- ► Publication of the book *Robert Davidson: Eagle of the Dawn,* edited by Ian M. Thom, a comprehensive overview of his work in a variety of media.
- ► Co-hosts a two-day celebration for urban Haidas, called "Urban Feast," in Vancouver.

ENDNOTES

1 *This symposium took place at the American Museum of Natural History, New York, in October 1991, in conjunction with the opening of the exhibit, "Chiefly Feasts: The Enduring Kwakiutl Potlatch."*

2 *The use of the word "primitive" both here and in Boas's publications was not intended to be pejorative; up until quite recently, this term was used to characterize the art of those cultures typically studied by anthropologists. Only within the last decade has that word been dropped from the vocabulary of scholars of First Nations art.*

3 *Hermann Haeberlin, "Principles of Esthetic Form in the Art of the North Pacific Coast: A Preliminary Sketch," American Anthropologist, 1918, vol. 20: 263-64.*

4 *These include: Marjorie Halpin,* Cycles: The Graphic Art of Robert Davidson *(Vancouver: University of British Columbia Press, 1979); Inuit Gallery,* Robert Davidson: An Exhibition of Northwest Coast Native Art *(Vancouver: Inuit Gallery, 1989); Derek Simpkins Gallery of Tribal Art,* Robert Davidson Exhibition: "A Voice from the Inside" *(Vancouver: Derek Simpkins Gallery of Tribal Art, 1992); Ulli Steltzer,* A Haida Potlatch *(Vancouver: Douglas & McIntyre; Seattle, University of Washington Press, 1984); Hilary Stewart,* Robert Davidson: Haida Printmaker *(Vancouver: Douglas & McIntyre; Seattle: University of Washington Press, 1979); Ian Thom, ed.,* Robert Davidson: Eagle of the Dawn *(Vancouver: Douglas & McIntyre; Seattle: University of Washington Press, 1993).*

5 Indian Artists at Work *(Vancouver: Douglas & McIntyre; Seattle: University of Seattle Press, 1976);* Coast of Many Faces *(Vancouver: Douglas & McIntyre; Seattle: University of Washington Press, 1979);* A Haida Potlatch *(Vancouver: Douglas & McIntyre; Seattle: University of Washington Press, 1984), and* The Black Canoe: Bill Reid and the Spirit of Haida Gwaii, *with a text by Robert Bringhurst (Vancouver: Douglas & McIntyre; Seattle: University of Washington Press, 1991).*

6 *Charles Fleurieu,* A Voyage Around the World Performed During the Years 1790, 1791, and 1792, by Etienne Marchand *(London: T. N. Longmans and O. Rees; reprinted New York: Da Capo Press, 1970), 281.*

7 *See Aldona Jonaitis,* A Wealth of Thought: Franz Boas on Native American Art *(Seattle: University of Washington Press, 1994), which reprints Boas's essays on art and situates them within the history of anthropological theory.*

8 *Franz Boas,* Primitive Art *(Cambridge: Harvard University Press, 1927; reprinted New York: Dover Publications, 1955), 1.*

9 *Aldona Jonaitis, "Franz Boas, John Swanton, and the New Haida Sculpture at the American Museum of Natural History" in* The Early Years of Native American Art History: The Politics of Scholarship and Collecting, *ed. J. Berlo (Seattle: University of Washington Press, 1992), 222-61.*

10 *Boas,* Primitive Art, *275.*

11 *Marius Barbeau, "How Raven Stole the Sun [Charles Edenshaw's Argillite Carvings],"* Transactions of the Royal Society of Canada, *1944, vol. 38:59-69. See also Marius Barbeau, "Haida Carvers in Argillite," Anthropological Series 38, National Museum of Canada Bulletin 139 (Ottawa: National Museum of Canada, 1957).*

12 *Steve Brown, "From Taquan to Klukwan: Tracing the Work of an Early Tlingit Master Artist" in* Faces, Voices, Dreams: A Celebration of the Centennial of the Sheldon Jackson Museum, *Sitka, Alaska 1888-1988, ed. P. Corey (Juneau: Division of Alaska State Museums, 1987), 157-76; Wilson Duff, "Mungo Martin–Carver of the Century,"* Museum News, *1959, vol. 1:3-8; Bill Holm, "Will the Real Charles Edenshaw Stand Up?" in* The World Is As Sharp As a Knife, *ed. D. Abbott (Victoria: British Columbia Provincial Museum, 1981), 175-200; Bill Holm,* Smoky-Top: The Art and Times of Willie Seaweed *(Seattle: University of Washington Press; Vancouver: Douglas & McIntyre, 1983); Peter Macnair et al.,* The Legacy: Tradition and Innovation in Northwest Coast Art *(Vancouver: Douglas & McIntyre; Seattle: University of Washington Press, 1984; Robin Wright, "Anonymous Attributions: A Tribute to a Mid-19th Century Haida Argillite Pipe Carver, the Master of the Long Fingers" in* Box of Daylight, *ed. Bill Holm (Seattle: Seattle Art Museum and University of Washington Press, 1983), 139-142.*

13 *The best book on this subject is Douglas Cole,* Captured Heritage *(Seattle: University of Washington Press; Vancouver: Douglas & McIntyre, 1985).*

14 *See, for example, Alan Hoover's appendix in Peter Macnair and Alan Hoover,* The

Magic Leaves: A History of Haida Argillite Carving *(Victoria: British Columbia Provincial Museum, 1984).*

15 Bill Holm, Northwest Coast Indian Art: An Analysis of Form *(Seattle: University of Washington Press; Vancouver: Douglas & McIntyre, 1965).*

16 For a more in-depth discussion of this issue, see Aldona Jonaitis, "Traders of Tradition: The History of Haida Art" in Robert Davidson: Eagle of the Dawn.

17 Franz Boas, "The Decorative Art of the Indians of the North Pacific Coast," Bulletin of the American Museum of Natural History, *1897, vol. 9: 123-76.*

18 Haeberlin, "Principles of Esthetic Form," 260.

19 Holm, Northwest Coast Indian Art, *29.*

20 Holm, Northwest Coast Indian Art, *93.*

21 Claude Levi-Strauss, "The Art of the Northwest Coast at the American Museum of Natural History," Gazette des Beaux-Arts, *1943, vol. 24: 175-82.*

22 This, for example, is why today I find fault with my first book, Art of the Northern Tlingit *(Seattle: University of Washington Press; Vancouver: Douglas & McIntyre, 1986). While I believe it contains useful material and interesting interpretations, it suffers from having been based on a salvage anthropological mould and having had no contributions from present-day Tlingit.*